DRAWING THE LINE

DRAWING THE LINE

What to Do with the Work of Immoral Artists from Museums to the Movies

Erich Hatala Matthes

OXFORD
UNIVERSITY PRESS

OXFORD
UNIVERSITY PRESS

Oxford University Press is a department of the University of Oxford. It furthers
the University's objective of excellence in research, scholarship, and education
by publishing worldwide. Oxford is a registered trade mark of Oxford University
Press in the UK and certain other countries.

Published in the United States of America by Oxford University Press
198 Madison Avenue, New York, NY 10016, United States of America.

CIP data is on file at the Library of Congress
ISBN 978-0-19-753757-2

DOI: 10.1093/oso/9780197537572.001.0001

1 3 5 7 9 8 6 4 2

Printed by Sheridan Books, Inc., United States of America

Art, like morality, consists of drawing the line somewhere.
— *G. K. Chesterton*

CONTENTS

ACKNOWLEDGMENTS

The first time I taught my own course on the philosophy of art was in the spring of 2014 at Wellesley College. I had designed a unit on the ethical criticism of art, focusing on whether the moral flaws of artworks could also be aesthetic flaws. The very first question that came up in class was whether the immorality of the artist could affect the aesthetic quality of the work as well—I've been thinking about the moral lives of artists ever since. So, first and foremost, I'd like to thank my students. Wellesley is a special place, and it has been a privilege and a pleasure to learn from the students here. Little about my philosophical writing would have been the same without them. I want to add a special shout-out to the students in my Calderwood Seminar in Public Writing who offered detailed feedback on the first two chapters of this book. You are models of how to boldly give and receive constructive criticism.

I benefited from the opportunity to present portions of this work to multiple audiences. Thanks are due to participants at the Dartmouth Workshop on Ethics and the Arts, the Bates College philosophy department, the Colgate University philosophy department, the Wellesley Club of Atlanta, and the Wellesley Club of the Pioneer Valley. Extra thanks to Kenny Walden, Paul Schofield, Anne Eaton, and James Harold. Thanks also to the

Pennoni Honors College at Drexel University and the Barnes Foundation for inviting me to participate in the panel "When Artists Behave Badly."

This work was supported in part by a summer fellowship from the Newhouse Center for the Humanities at Wellesley College. Thanks to the other fellows, and to all of my colleagues at Wellesley. Special thanks to my fellow Wellesley philosopher Julie Walsh, who was the first person to read a draft of the book from cover to cover.

I am tremendously grateful to my editor at Oxford University Press, Lucy Randall, who was the sine que non of this project. Thank you for providing supportive and incisive feedback, for answering my never-ending questions, and for suggesting that I write this book in the first place. It has been an absolute pleasure working with you. Thanks also to Hannah Doyle and everyone else at OUP who made this book possible.

I was in the middle of writing this book when the COVID-19 pandemic hit. Like many, we were without childcare for months, which made progress . . . challenging. So, the most effusive thanks to Sarah Matthes and Jesse Bradford for driving all the way from Texas to Massachusetts (sleeping in the back of their truck for safety) and staying with us for over a month to help keep the cabin fever at bay, entertain our kid, and give me a chance to keep writing. I think it's the longest that my sister and I have been under the same roof since we were kids—it was an absolute blast. And thanks, Sarah, for your feedback on the manuscript, too! Similar thanks are owed to my amazing Mom, who also spent countless hours helping with childcare (after periods of two-week quarantine, of course). Thank you for uprooting your life to be closer to

us; I love seeing you so often, and there's nothing your grandchild enjoys more than a visit to Grandma's! Thanks also to my Dad, who readers will have the pleasure of meeting briefly in the last chapter of this book. Dad, I miss you.

This book was nourished in important ways by our fantastic child: to quote one of our favorite children's book authors, Kevin Henkes, you are an indescribable wonder. The person who puts up with the most, of course, is Jackie Hatala Matthes. Thank you for your support, your kindness, your love, your brilliance, your cooking, your silliness, and your pro-parenting, not to mention your feedback on this book. I love you.

Last but not least, thanks to Team Boo.

| INTRODUCTION

For most of my life, I've thought of *Love and Death* as my favorite movie. It's a 1975 satire about Russian literature featuring humor that runs the gamut from highbrow referential comedy, to slapstick, to what could only be described as dad jokes. It's also full of explicitly philosophical discussions, so as a philosophy-minded adolescent who went on to become a philosophy professor, I was no doubt predisposed to like it. I don't think it's a famous movie, exactly, so you may not be familiar with it. *Love and Death* stars, and is written and directed by, Woody Allen.

For me, *Love and Death* is what the kids these days call a "problematic fave." Woody Allen has been accused of molesting his then-4-year-old adopted daughter, Dylan Farrow, and he ultimately married Soon-Yi Previn, the daughter of his erstwhile partner Mia Farrow, a relationship that officially began when Previn was an adult, but ostensibly started when she was younger and Allen was in a parental role. Whatever you think about the details of these allegations, Allen has developed a reputation for having a deeply unsavory moral character. I am disturbed and disgusted by Allen, but I love *Love and Death* (not to mention other classic

Allen films such as *Hannah and Her Sisters* and *Annie Hall*). The juxtaposition of these beloved artworks with their unethical creator leaves me feeling confusion, nostalgia, anger, and betrayal. And I'm not sure how to feel about any of that.

This book is an attempt to sort through those thoughts and feelings, using the tools that I know best: the tools of philosophy. While the details of this story may be unique to me, I imagine all of us have been affected in various ways by the revelation that artists whose work we love have done terrible things. What should we do, think, and feel in response to this knowledge? I can't promise a simple or straightforward answer to these questions. But I can offer arguments and reflections that I hope will allow you to arrive at your own conclusions about immoral artists and the roles they play in our lives. Reflecting on these questions has led me to certain positions that I'm convinced by, but other issues are still vexing. Another of my goals in this book is to articulate why I think easy answers are elusive, to help you feel the force of the same tensions that I feel.

I want to be clear at the outset about what I will *not* be doing in this book. I won't be investigating, reporting on, or assessing the legal case for or against the actions of any particular person. I am as far from being an investigative journalist as I am from being a firefighter or an astronaut. I will use a range of real examples, but my aim is also not to explain why any specific artist has acted immorally. While that's at least squarely in my wheelhouse as a philosopher who specializes in ethics, it's a different project from the one I have in mind here. Instead, I will focus on questions that arise from the assumption that an artist's actions are morally

wrong. So just take for granted that Allen, for instance, has acted wrongly: Where do we go from there? This focus will allow me to mostly avoid rehashing too many of the graphic details surrounding the behavior of famous artists, but as in the case of Allen, they will unavoidably be mentioned. Every chapter of this book mentions sexual assault in some way, and I want readers to be aware of that before getting started.

This book is also not comprehensive. There will be many relevant examples and arguments that are not included or arise only in passing. My aim is to guide your thinking through some helpful considerations in an engaging way: it's not to provide an exhaustive survey of the logical space. You will no doubt think of cases that I don't discuss here. That's good! You can use those to test out some of the proposals I float in the coming pages.

Some readers of this book will be eager to hear about "cancel culture," a term that has settled over discussion of immoral artists like a fog, obscuring the details of the difficult issues surrounding this topic. I'll try to dissipate that soupy mess in Chapter 3, but most of this book isn't directly about whether or not immoral artists should be "canceled," whatever that ultimately means. Pushing beyond the cancel culture framework provides us with space to explore a host of other fascinating questions: Do the moral lives of artists affect the aesthetic quality of their work? Is it morally permissible for us to engage with or enjoy that work? How should we sort through our conflicting emotions when artists whom we love do or say terrible things? Grappling with the nuances of these questions will put us in a better position to understand why, for example, it might make sense for a museum to cancel an upcoming

exhibition by an artist accused of assault, but not for his work to be removed from every gallery in the world.

I've been teaching courses in moral philosophy for over a decade, and students always arrive in the classroom with some questions about moral language, particularly about the relationship between "morality" and "ethics." I used to refer to a scene in *Election* while answering this question, but apparently no one under the age of 35 has seen that movie (Reese Witherspoon fans, don't sleep on this one). So, just know that I will use "unethical" and "immoral" interchangeably for stylistic variety, but the discussion here assumes no distinctions in their meaning. Same for "aesthetic" and "artistic." There are all kinds of ways to distinguish those terms, but here you can just treat them as synonyms.

There's a comic from Bill Watterson's *Calvin & Hobbes* where a disgruntled Calvin mopes: "A good compromise leaves everybody mad." I didn't set out to broker a disagreement between factions in this book, but it does in some ways feel like a compromise because I remain torn about the issues. On the one hand, I'm fed up with people in positions of privilege, as famous artists typically are, taking advantage of their stature to exploit the less powerful or to promote hateful views. But I also love art and believe that standing up against predators and bigots doesn't require us to sacrifice art in the process. G. K. Chesterton once wrote: "Art, like morality, consists of drawing the line somewhere." I think that if we draw the lines in the right places, we can render our commitment to morality and our love of art consistent with each other, but it's a challenging picture to compose. You might not be fully satisfied with how it looks in the end. But even if the picture that

I present here doesn't completely appeal to you, I hope that it will provide useful guidance and inspiration for how you might sketch your own vision of things. Where will you draw your lines? After all, we need to put them somewhere, or risk being left without art, or morality, altogether.

SYMPATHY FOR THE DEVIL

DO IMMORAL ARTISTS MAKE
WORSE ART?

Imagine it's 1994. You probably didn't even have internet access yet, let alone a cell phone, so you're killing time listening to the radio. A song comes on by a breakout pop/R-and-B artist: Aaliyah. You've heard her music before, but this is the third single from her debut album, and it's new to you. You're bobbing your head and admiring the vocals when you start paying more attention to the lyrics. You hear her youthful voice weaving words into a confident seduction, culminating in an assurance, echoed in the title of the song, that her "Age ain't nothing but a number."

Your brow furrows for a moment. You think: wait a second— exactly how old is she? Because depending on the answer, her age might be a whole lot more than a number! Later that night on MTV, you learn that Aaliyah is 15, and the song you were listening to was written and produced by a 27-year-old man to whom Aaliyh is secretly married. He's already a star in the music world. His name is R. Kelly.[1]

While you may already have been hesitant about the lyrics, knowing all the facts has the potential to influence your experience

of the song. It's morally wrong for a powerful man to sexually exploit a girl who depends on him for a shot at her dream. The next time the song comes on the radio, maybe you'll switch to a different station. "Ugh!" you might say: "I just can't listen to this!"

If you've had an experience like this one, where something that you've learned about an artist's behavior leads you to question or reject their work, then you'll likely agree that there are times when you just can't separate the art from the artist. Turning away from an artwork in disgust is both a moral and aesthetic response: you're not just making a moral judgment about the artist—that judgment is shaping your reception of their artwork as well. This kind of response isn't guaranteed, of course. You might instead think: "R. Kelly is a creep, and these lyrics are kind of gross, but man, I love this song!" That would be a moral condemnation of the artist, even a moral condemnation of the song, but not an aesthetic criticism of it: you think it's a good song despite R. Kelly's actions and the kind of relationship the song endorses. But if you have a visceral negative reaction to the song, finding it can no longer move you or engage you, feeling the urge to turn it off, then it seems that the moral flaws of R. Kelly and the song have infected its aesthetic. Not only is R. Kelly subject to justified moral criticism for exploiting an underage girl, but his artwork celebrating that exploitative relationship inherits the same condemnation—the artist's immorality has soured the music you would have otherwise enjoyed.

This case turns out to be a kind of perfect storm, where the misdeeds of the artist, the moral message of the lyrics, and the role of those lyrics in the aesthetic success of the song all come together

to produce an effect that is disastrous. Things don't always come together so neatly. It's plausible to judge that R. Kelly's actions make this song subject to both moral and aesthetic criticism, but it's uncommon for a situation to tick all the boxes that make this combination of judgments apt, and there's plenty of disputable interpretive work involved in justifying them. In other words, the moral flaws of artists do not *automatically* render their work aesthetically worse. This makes it much more complicated to understand how to answer an important question: What do we do with the work of immoral artists?

In the case of R. Kelly, we've seen that there are three different kinds of criticism we can apply: moral criticism of a person (the artist), aesthetic criticism of an artwork, and moral criticism of an artwork. The first two categories are pretty familiar—we're used to judging that some guy is a jerk, or that a novel is cliché. But what does it even mean to say that *an artwork* is morally bad? We reserve moral criticism for people, not objects. The knife-wielding murderer is bad—the knife is just a knife in the wrong place at the wrong time. We might chastise a friend for frivolously breaking a promise or condemn the opportunistic killer (the first kind of criticism), but when we say that a painting or movie is bad, we usually have something entirely different in mind. When it comes to artworks, our value judgments typically have a distinctively aesthetic flavor: we criticize hollow acting, clunky writing, unimaginative stories, and off-key singing (the second kind of criticism). Does it make sense to add moral flaws to that kind of list? That would be the third kind of criticism—moral assessment of the artwork itself. By comparison, even events that can have devastating consequences on human life don't seem like they're subject to

moral criticism. To be sure, it's a tragedy when an earthquake kills thousands of people, and we will all agree that a horrible thing has happened. But we don't think the earthquake itself is morally bad: it hasn't done something wrong in the way that a terrorist who intentionally kills thousands of people has done something wrong. And while a person is responsible for the creation of the artwork, the artwork itself is an inanimate object in the case of a painting or sculpture, or an event in the case of a performance. While we might judge that the creation of an artwork has a bad *outcome* and hold the artist morally responsible (say, a movie or novel that intentionally incites violence), that's different from saying that the artwork itself is morally bad. After all, if it doesn't make sense to say that something with consequences as disastrous as an earthquake is morally bad, you might wonder how it could make sense to judge that an artwork is morally bad.

The difference is that artworks, unlike earthquakes, can take up a particular perspective on the world. Tectonic plates don't have a point of view, whereas an artwork can offer us scenarios and entreat the audience to respond in specific ways. Think about religious art that presents a saint or icon to be venerated. Or consider a tragic hero, perhaps Daenerys Targaryen from *Game of Thrones*, who is meant at turns to be praised, pitied, and feared. Because these works call on the audience to have certain responses to their content, we can ask whether those responses are fitting, morally or otherwise. Sometimes, the response that an artwork encourages us to have toward a character, for instance, chafes with how that character is represented: they're painted as the villain but actually appear sympathetic. Other times, we find that the perspectives adopted by a work of art are themselves morally objectionable: a

song can endorse misogynistic attitudes, a movie can glorify racist violence. Because misogyny and racism are morally condemnable, we can criticize these works in turn for presenting a morally objectionable perspective on the world and asking the audience to adopt it, too. In other words, it turns out we can give sense to the idea that these artworks are subject to moral criticism after all.

Thinking that artworks can be morally bad because of the perspectives that they adopt is a pretty familiar idea these days, but it wasn't always so. While philosophical reflection about the morality of art in the European tradition dates back to at least Plato and continues through the work of figures such as Hume and Tolstoy, there was a time not too long ago when such questions were effectively off the table. Early to mid-20th-century aesthetics was under the sway of formalism, the view that the nature and purpose of art did not extend beyond the formal features of the work and the relationships among them. Painting was about line, shape, color, arrangement, and the way that these formal features evoked a distinctive aesthetic response in the viewer, one that was "disinterested." This did not mean that viewers should not be interested in the work of art (formalists definitely thought that art was interesting!), but rather, that their concern should be with the formal properties of the work alone, while any and all contextual features (one's own desires, the history of the work, its moral and political context, and any facts about the artist themself) should be left out of the frame. This was the era of art for art's sake.[2]

It's no surprise that advocates of art for art's sake would not think artworks can be subject to moral criticism: if the only proper objects of artistic attention are the formal features of the artwork, then any moral message that might be found in the work

will be excluded as irrelevant. It's also no coincidence that the rise of this view coincided with the prominence of artistic styles such as abstract expressionism. It's easy to claim that the ethical features of a work are irrelevant when you're talking about a Rothko color field or a Pollock drip-painting, neither of which seems to have any ethical content in the first place.

It's harder to maintain this view when it comes to artworks that are explicitly trying to engage the audience's capacity for moral reflection. To insist that ethics just has nothing to do with *Othello* or *Guernica* or *Mean Girls* seems to entirely miss the point of these works. The influence of formalism was predictably short-lived, and in recent decades philosophers and other experts have returned with gusto to examining questions about the ethical criticism of art.

However, once we've agreed that it's at least possible for artworks to be morally bad, we're faced with a different question: Does the fact that artworks can be subject to such moral criticism make these artworks worse *as artworks*, or as I put it earlier, worse aesthetically? Do the lyrics to "Age Ain't Nothing but a Number" make the song not just morally worse, but aesthetically worse, too? Formalists didn't think it made sense to criticize the ethical content of an artwork at all, let alone bother with thinking through the relationship between that content and the work's aesthetic quality. To address this question, philosophers and other commentators have had to develop novel ways of thinking about the relationship between the moral flaws of an artwork and the potential aesthetic consequences of those flaws. Is there a way to explain why a song that endorses sexual exploitation is rendered aesthetically worse by that perspective? This on its own presents a

philosophical challenge, but figuring out the relationship between the moral flaws of *artists* and the aesthetic success of their work is a further task—one that deserves attention now more than ever. Especially after the revolutionary #MeToo movement has brought many misdeeds of artists to light, we need to think through what the morality of artists has to do with the moral and aesthetic dimensions of the work they produce. How does ethical criticism of artists influence the aesthetic success of their artwork? Do the moral failings of artists make their artworks worse? Are Woody Allen's movies less funny? Are Michael Jackson's hits less dance-worthy? Would it make sense to turn away in disgust from "Age Ain't Nothing but a Number"? How can we begin to think through the changes in our aesthetic behavior that moral revelations about artists can seem to invite?

The problem we face in trying to explain the relationship between the moral and aesthetic features of the *artwork* is that it can seem natural to keep these two kinds of criticism separate. For instance, we might agree that a song like "Blurred Lines" endorses a morally objectionable view about consent but not think that makes it a worse song. We might cringe at the lyrics even as we tap our feet to the beat. Leni Riefenstahl's *Triumph of the Will* is often identified as an artistic masterpiece, despite the fact that it was a paean to Hitler. In other words, we might think that ethical and artistic criticism occupy two separate domains that just don't have anything to do with each other. The differing force of moral and aesthetic criticism might further support this view. We all tend to agree that murder for pleasure is wrong, but disputes about the artistic success of *Moby Dick* involve a lot more room for interpretation.

Those who want to argue that the moral content of an artwork does bear on its artistic quality have to find a way to bridge the apparent gap between the ethical and the aesthetic, and this can be challenging. This problem parallels the gap that we face in trying to explain how the moral character of the *artist* could affect the quality of their work: How do we establish that the kind of criticism that artists are subject to (e.g., R. Kelly exploited young women) influences the kind of criticism that artworks are subject to (e.g., "Age Ain't Nothing but a Number" is creepy)? If we can bridge the gap between the ethical content of a work and its artistic quality, perhaps we can use the same bridge to connect the ethical character of the artist with the artistic quality of their work. In order to see if this strategy can yield fruit, we need to begin by considering how the divide between the moral features of an artwork and its aesthetic quality might be overcome.

According to one influential approach to the ethical criticism of art (championed by philosopher Berys Gaut), we can bridge the gap between the ethical and the aesthetic by looking to what the work asks of us. Many works of art aim to elicit specific responses to the work: they urge us to feel certain ways or think particular thoughts. We can see a clear illustration of this when we look to artworks in particular genres. A comedy asks the audience to find the work humorous; a tragedy entreats us to grieve for the fate of its characters. But if the immoral content of a work would make it wrong to have the prescribed response (or perhaps render us incapable of having the prescribed response), then we might rightly judge that to be an artistic failure of the work. The artist has a set of artistic goals for their work: failing to meet those goals certainly seems like an artistic flaw.[3]

Of course, a work of art can fail to elicit a certain response for reasons that have nothing to do with morality. Sometimes works that claim to be comedies are simply not funny. When a comedy bombs, that's clearly a failure of the work. We might find ourselves laughing *at* it because it's so bad, but that's not the right response either, even if it superficially looks the same. Laughter is often the response we have to failure, sometimes because failure is awkward, sometimes because it's absurd. And we tend to laugh at failures in genres besides comedy as well. The movie *Manos: The Hands of Fate*, famously mocked by the team at *Mystery Science Theater 3000*, is ostensibly supposed to be a horror flick, but it's so fantastically bad that it's hilarious. The *MST3K* crew made comedy out of failed horror and sci-fi movies, but those movies were not trying to be funny. They were genre failures, movies that missed the mark on the one feature definitive of their genre.

But now, consider a comedy that is racist (or sexist, or has some other moral flaw). The fact that the comedy is racist is a reason not to be amused by it: racism is not funny. We therefore have reason not to respond to the comedy in the way that it's entreating us to respond. Morally speaking, we shouldn't laugh. We've already seen that when a work tries to elicit a certain response and fails, we can call that an aesthetic defect of the work. But just as a joke can fail to be funny because it's corny or because the timing is off, a joke can fail to be funny because it's racist: those are all features of the work that prevent it from being funny. And so, we've arrived at a potential connection between the moral content of a work and its aesthetic quality. When an artwork tries to elicit a certain response in the audience, but also gives the audience a reason not to have that very response, that's an artistic failure

of the work. When an artwork has a moral flaw, that gives the audience a reason not to respond in the way the artwork is asking them to—specifically, because it would be wrong to have that response. This is what philosophers call a *normative* approach to the puzzle, because it concerns how we *ought* to take moral features into account when responding to an artwork. It bridges the ethical/artistic gap by showing us that the ethical flaws of a work can undermine whether the work merits the aesthetic response that it's aiming for.

You may be worrying that the example we've just looked at seems to suggest that morally objectionable humor isn't funny. But morally objectionable humor can be funny, as we all know! A lot of humor operates by toeing (and sometimes crossing) the line of what's considered appropriate, including what's considered morally appropriate. So, if the view on the table tells us that morally objectionable humor isn't funny, there must be something wrong with the argument for it. Doesn't that make this whole theory wrong?

Thankfully, no. The normative approach does not dictate that we should find morally objectionable humor unfunny. It does suggest that the immoral content of the work can sometimes give us *a* reason not to find it funny. The work can still be funny, even very funny. But according to this view, because we have *some* reason not to respond in the way the work is asking us to respond, that is to some extent still an artistic flaw of the work. That awkward feeling when you're laughing at a morally objectionable joke, but also kind of wincing at the same time? That's you being responsive to your reason not to laugh. The joke may still be funny, all things considered, but you're not all-in on your response, and to

that extent, the joke hasn't fully succeeded. (You may think the fact that the joke managed to be funny despite its moral cringe-worthiness is actually a point in its favor. We'll return to this idea later.)

I claimed earlier that the racist content of a joke can give the audience a reason not to find it funny because racism is not funny. As you might point out, though, there's a whole genre of political humor that is explicitly aimed at finding the humor (tragic though it may be) in otherwise immoral situations, like racist ones. Successful comedians like Dave Chappelle, Wanda Sykes, Chris Rock, and Margaret Cho illustrate this point. Because racism can be funny in the right hands, it doesn't follow that the racist content of a joke gives us a reason not to find it humorous.

While it can be possible to deploy racism in a way that works on a comic level, this fact doesn't undermine the normative approach. This is because we can distinguish between the attitudes *represented* in a work and the attitudes *prescribed* by the work. Racist humor prescribes that we ourselves adopt racist attitudes and ideas and find humor in doing so. But this is not what political humor does, at least when it avoids embracing racism. Rather, it represents racist attitudes, and then pokes fun *at* them. This is also a defining feature of political satire more broadly, but satire does not prescribe that we adopt or endorse the political institutions that it critiques.[4] The HBO comedy *Veep* is a masterclass in toeing the line between morally objectionable content that is represented but plausibly not endorsed by the show. So, the presence of morally objectionable content does not on its own pose a problem

for the normative approach—it depends on how the artwork uses that content.[5]

There's a more sophisticated reason that you might object to this theory, though. You might think that while the immorality of a comedy could give us a *moral* reason not to laugh, that's completely separate from the features of the artwork that make it funny.[6] So even if you would be subject to moral criticism for laughing at the racist joke, that has no bearing on how funny the joke is one way or the other. In other words, the moral merit of a response is distinct from other kinds of emotional response an artwork might earn, and the normative approach to the moral-aesthetic relationship only works by conflating these separate categories. Think about this for a minute: Butter is absolutely delicious, but most modern dairy practices involve horrific abuse of cows. So, you could say we have a moral reason not to respond to the deliciousness of butter in the typical way, namely, by eating it, cooking with it, and appreciating its delectable richness. But this moral prescription about what we should do (or not do) with butter doesn't make butter any less delicious: the moral reasoning that is relevant to how we ought to treat butter seems wholly independent of the fittingness of our gustatory response ("Yum!"). Indeed, that's one of the barriers that keeps us all from just becoming vegans.

But, you might be wondering, is it always true that our emotional and aesthetic responses can be separated from our moral responses so easily? Some of the emotional responses that artworks call for are inextricably linked with moral judgment.[7] While savoring the taste of butter has no inherent relationship

with moral thinking, emotions like contempt and sympathy, key to the aesthetic appreciation of many narrative artworks, very much do. It doesn't make sense to feel contempt toward something that you don't at least perceive as being an affront to you. This doesn't necessarily get us out of trouble with the case of humor, since it's not clear that finding something funny has this kind of moral dimension, but just because an emotional response isn't inherently bound up with morality doesn't mean we can't morally criticize that response.[8] For instance, claiming that a racist or sexist joke is not funny is a pretty common response to such humor. Unless we want to insist that such responses don't even make sense or aren't meant literally, we need to make room for the possibility that humor is to some extent bound up with morality.[9] In any event, plenty of emotional responses that artworks call for clearly relate to morality, so we could still claim in those cases that the moral features of the artwork bear on whether we ought to have the prescribed response.

You might start to worry about all this talk of criticizing our emotions and judging whether they make sense. Are emotions supposed to "make sense"? Don't I just feel what I feel and that's that? While it is no doubt a bad idea to run around telling people that their feelings don't make sense (if you doubt this, feel free to try it out and see how it goes), we do often think that our emotions can be more or less apt. For instance, imagine you were really looking forward to having some ice cream, but you open the freezer to discover it's gone! You might get angry at your spouse for cleaning out the ice cream supply. But then, imagine your spouse points out to you that the ice cream is still there, it's just hidden under the frozen pizza. Your anger would no longer make sense. On

the contrary, now you might feel quite sheepish. So, evaluating whether our emotions make sense really isn't so unfamiliar.

I've been using the example of comedy to illustrate how the normative approach to the moral-aesthetic relationship works, but this idea applies across the full range of responses that artworks aim to elicit. A work that entreats us to sympathize with a murderer or be elated by oppression would be subject to the same concern: the work asks us to respond in a way we have moral reason not to.

Now that we have a grip on how the normative approach works with morally flawed art we can move on to the next step. We want to know whether we can use this approach to explain whether and why the moral flaws of artists themselves can result in artistic flaws in their works. Is this the right way of thinking about the ethical criticism of artists, too?

You might think that we can straightforwardly apply the normative approach to the case of morally flawed artists. Just as the immoral content of an artwork can give us a reason not to respond in the way the work prescribes, so too can the moral failures of the artist. Alas, not so fast! It turns out that the application of this framework to the case of artists presents a number of challenges that need to be addressed .

First, there is a worry about the relevance of the artist's life to the interpretation of their work. The moral content of an artwork itself matters because it's directly related to the response that the work is aiming for us to have: it's the joke that is racist, it's the devil we're supposed to sympathize with. There's a clear connection between the response prescribed by the artwork and the moral content of the artwork. But the moral flaws of the artist

often don't have anything to do with the response prescribed by the artwork. You may know that Adolf Hitler, before becoming a genocidal dictator, was a failed painter. His paintings are nothing to write home about, and they're certainly not immoral: they consist mainly of quiet cityscapes. What could Hitler's immoral character possibly have to do with his paintings? Do we have reason not to find Hitler's paintings tranquil because of his egregious immorality? Why?

Even when we're talking about someone as evil as Hitler, we can't just assume his immorality is relevant to the art he made. The relevance of the artist's immorality needs to be *established*. Though it is unclear why facts about Hitler should be relevant to how we ought to respond to his paintings, in other cases we can tell a compelling story about how the artist's immorality directly relates to the content of their work.[10] In the case of R. Kelly, there's a direct relationship between moral criticism of the artist and the content of a number of his songs. With "Age Ain't Nothing but a Number," we might already be hesitant about the lyrics, but knowing what we know about R. Kelly seems to give us additional reason not to have the response that the music is aiming to elicit.

Or compare the case of Woody Allen—someone who may have been on your mind since you started reading this book. Allen is married to Soon-Yi Previn, the adopted daughter of his former partner Mia Farrow, a relationship that ostensibly began when Previn was a young adult (21) but even so presents a morass of moral concerns about exploitation and abuse of power. (Allen has also been accused of molesting his then 4-year-old adopted daughter, Dylan Farrow.) The fact that Allen frequently casts himself as the male love interest in his films alongside much younger women

may already make you feel icky (not to mention test your ability to suspend disbelief). But if on top of that Allen has engaged in a morally questionable relationship with a young woman in real life, we may have additional reason not to empathize with the portrayal of such relationships in his films.

But why is that? Why should the fact that the artist's actions reflect the content of their work have any bearing on how we should respond to that work? One answer is that it raises the moral stakes of the artwork by engaging the audience in a more specific project, one aimed at redeeming the artist themself. A work that asks you to empathize with a character who exploits their power for sexual gain, made by an artist who exploits their power for sexual gain, seems to be part of a project of moral redemption for the artist. It takes the perhaps abstract worry about adopting morally objectionable attitudes in the context of an artwork and makes them more concrete by applying them to a specific, real-life individual. In "Age Ain't Nothing but a Number," Kelly is using his actual child bride as a mouthpiece to vindicate his exploitative relationship with her—she's being exploited all over again. Insofar as we have moral reason to reject such a project, we have extra reason not to respond in the way the artwork prescribes, namely, by finding it sexy: not only because such a response is morally objectionable in principle but because that very in-principle objection has been given a real-world application.

A more general way to put this point is to say that the moral flaws of the artist matter to the aesthetic success of their work only when they influence or alter its meaning.[11] Consider how we might respond to the moral flaws of an athlete. While we rightly reject Michael Vick's abuse of animals, and it's obviously morally

wrong, this doesn't clearly have any bearing on how we should regard his athletic achievements. By contrast, Lance Armstrong's doping is morally wrong, and specifically wrong in a way that is directly relevant to his sport. We think less of his Tour de France record because he achieved it through an unfair advantage—it thus alters the meaning of his success. This distinction, so clear in the context of athletics, can be applied in the world of art as well. When artists use their work in order to defend their own immorality, that shapes the meaning of the work, and in this way can bear on its aesthetic success.

In some cases, the use of an artwork to defend the artist's immorality will be intentional—that certainly seems to be the case for R. Kelly. But the artist doesn't need to intend for their work to ensnare the audience in a redemptive project in order for the work to have that effect. Whether we should defer to the artist's intention in interpreting their work remains controversial.[12] But even if you don't think this is the intended aim of Woody Allen's *Manhattan*, for instance, it doesn't take much imagination to see a movie that normalizes sexual relationships between middle-aged men and teenage girls that is written by, directed by, and starring an individual criticized for this very kind of relationship as having the effect of defending Allen's real-life behavior.[13] It can be the context, as opposed to the intention of the artist, that makes the work function as a defense of the artist's moral misdeeds. Insofar as this context introduces reasons for the audience not to respond to the work in the prescribed way (such as treating the depicted relationship as morally acceptable), it is an aesthetic flaw in the work.

Ensnaring the audience in a redemptive project is one way that the artist's biography can influence the meaning of their work, but it's certainly not the only way. Indeed, sometimes the artist's biography can actually remove the appearance of moral skeeviness—that's a technical term—from a work. For example, consider a song with the same kind of lyrics as "Age Ain't Nothing but a Number," but written and performed by Jennifer Lopez for a boyfriend 18 years her junior. We might then interpret the lyrics as bold and romantic, bucking sexist double-standards about age and desirability rather than raising issues of consent or exploitation. Or consider if we interpret the lyrics to the original song simply as the fantasy of a 15-year-old Aaliyah, factoring the whole R. Kelly situation out of the picture. Fantasizing about older people (movie stars, pop icons, etc.) is a defining feature of adolescence. It's not the fantasy that's wrong—it's our understanding that the relationship is real that pushes the song over the moral line. So, what we know about the artist can influence plausible interpretations of their work in a host of ways, for (morally) better or for worse.

Let's go back to the case of comedy. As we saw, comedians are engaged in the practice of navigating lines of appropriateness in order to produce humor—blaming them for sometimes crossing the line in the course of that task calls into question their very vocation, an issue we'll return to in Chapter 3. But whether a joke would cross the line or not in its content alone, the relationship between content and reality can affect where the line gets drawn. Consider this memorable moment in the movie *Stand and Deliver*. A bunch of underserved high school kids are being pressured to confess to cheating on their AP Calculus exam, which they didn't

do. Finally, one of them does confess to something: he confesses to getting a copy of the test ahead of time by stealing it from the mailman, killing him, and stuffing the mailman's body in his locker! Because the line is expertly delivered, it's clear to everyone (including the audience) that this was a joke. And what's funny about this is not the idea of killing the mailman per se, but rather the absurdity of the (false) confession under the circumstances. If the student had actually killed the mailman, this would not be a funny thing to say! In fact, delivering the confession as a punchline if it were actually true would be all the more perverse. Comedians and other artists find themselves in an analogous position. Jokes that would toe the line under the presumption of innocence can cross the line when the artist is in fact guilty, because they can alter the meaning of the work. Louis C. K. recently joked during a set: "I like to jerk off, and I don't like being alone."[14] Whether there is some context in which that could be a funny joke I'll leave up to the reader: but I think it clearly becomes unfunny when delivered by a comedian who has admitted to masturbating in front of multiple women under morally problematic circumstances. Facts about the artist can move where the line of appropriateness is drawn.[15]

Perhaps the clearest way to see that facts about the artist can influence our interpretation of their work is to focus not on the artist's actions, as we have so far, but on their beliefs. In fact, upon reflection, it's not so clear that an artist's misdeeds would bear negatively on our interpretation of their work *unless* they were an indicator of the artist's immoral beliefs. For instance, imagine an artist who committed murder, but wracked with remorse, spends the rest of their life creating artwork that earnestly attempts to

grapple with their guilt and shame. The artist's biography is clearly relevant to the meaning of their work, but not in such a way that their moral misdeed (murder) would negatively impact their work. Now compare this with an artist who relished killing and gleefully depicts scenes of their own murders, inviting the viewer to share in their sadistic pleasure. We might plausibly have reason to resist the response the artist is trying to elicit. The point is that when we suppose that an artist's immoral action could be relevant to the success of their work, it seems to be because they *endorse* their own immoral behavior.[16] This is easiest to see in cases where the artist employs their artwork as a defense of their own actions. What grates about Louis C. K.'s masturbation joke is that it indicates that he *doesn't think he did anything wrong*.

But this observation also suggests that we should be careful about how we interpret the relevance of an artist's actions to the meaning of their work. People make a lot of moral mistakes. There's nothing inherently wrong with exploring those errors through art; indeed, that we can do so is one of art's great values. As philosopher Christopher Bartel notes, sometimes the moral hardships of artists yield more positive aesthetic evaluations of their work, as he suggests is the case with Johnny Cash.[17] There's no reason to assume that morally flawed people make aesthetically worse art; rather, it's the *way* that an artist's immorality enters their work that can be relevant to its meaning, and hence to its aesthetic success.

This is the point where some savvy reader (likely a former English major) raises their hand and says: "But I heard that the author is dead?"[18] It is true that certain strands of literary and artistic criticism have attempted to dethrone the role of the artist,

urging readers not to think of the artist and their biography when consuming and critiquing their art. But the idea that we should be wary of overemphasizing the intentions or biography of the artist in our interpretation of their work doesn't require that we completely disregard it. Indeed, the idea that facts about the lives of artists can be relevant to interpretation of their work is utterly familiar in contemporary art criticism. For example, consider Baroque painter Artemisia Gentileschi's visceral depictions of Judith beheading Holofernes. Knowing that this painting was made by a woman can inform how we interpret it (as compared with the many more anodyne depictions of this same scene by male artists). Knowing about the difficult position of female artists in 17th-century Italy adds something more. Knowing that Gentileschi was raped by her art tutor Agostino Tassi, and that there is a resemblance between Gentileschi and Judith and between Tassi and Holofernes, offers an additional lens for interpretation. Of course this knowledge can influence how we interpret Gentileschi's work![19] It doesn't need to be the only lens through which we view the painting, and there may well be dangers in restricting our interpretive focus in this way, but it's certainly *a* lens we can use, and knowing these facts can add depth to our appreciation of the art.[20] Given how readily we can see the relevance of an artist's biography in a case like Gentileschi's, it's surprising how resistant some commentators can be to the idea that an artist's immorality could (not must) be relevant to the meaning of their work as well.[21]

So, it looks like we've arrived at an answer to our question. We can build the bridge between the moral flaws of the artist and the artistic flaws of their work on the scaffolding provided by the

normative approach to thinking about how the moral flaws of an artwork can make it aesthetically worse. When the immoral acts of the artist generate or strengthen reasons for the audience not to respond in the ways prescribed by the work because they alter the meaning of the work itself, then the artist's moral flaws can actually make the artwork less successful. Such considerations will never be decisive; interpretation of an artwork's meaning will always be a matter for debate, but the normative approach provides a strong foundation for treating the moral lives of artists as potentially relevant to that interpretative task (as we'll see in the next chapter, this is one reason why actually engaging with their art is so important). This will be particularly clear when it seems that the artist is employing their craft in order to mount a defense of their own immorality. We can have extra reason not to sympathize with the devil in the artwork when the artwork issues from the devil's own hand.

The weight of the normative approach rests on claims about how you *ought* to respond to works of art. But what if you're skeptical about this whole normative way of thinking about art? You might think there's no sense to be made of how you "ought" to respond to a work of art. Where would such standards come from? You just have the response that you have. So, what we should really be paying attention to is whether knowledge of an artist's immoral character actually does affect an audience's engagement with the artist's work. By attending to the descriptive matter of how audiences actually respond, we can avoid the messy normative question of how they ought to respond.

Luckily, there is a cousin of the normative approach that fits the bill. Let's call it the descriptive approach. It shares a similar

structure with the normative approach, but it shifts the focus from considerations of how audiences *ought* to respond to a work to observation about how they actually *do* respond. In other words, it asks us to *describe* the audience's actual response to the artwork and make our assessments about the moral-aesthetic relationship on that basis. As with the normative approach, we can begin with the claim that artworks are often trying to elicit certain responses from the audience. In the case of narrative artworks in particular, we can describe a general response that the artworks are aiming for; namely, they endeavor to engage us in the story. They want us to enter into the imaginative world of the artwork, and in doing so, to perhaps accept certain imaginary propositions (dragons exist!). However, sometimes the immoral content of a work can lead us to resist this imaginative engagement with the narrative. When the moral flaws of an artwork ratchet up our imaginative resistance, inhibiting or preventing our ability to engage with it, then that is an artistic failure of the work. As with the normative approach, on the descriptive approach we can still contend that a work can be flawed due to its lack of success in achieving its artistic aims. But unlike the normative approach, according to which we claim that the work is flawed when it gives the audience a *reason* not to respond in the prescribed way, on the descriptive approach we claim that the work is flawed when the audience actually fails (wholly or partially) to respond in the right way, independently of any claims about what they ought to do.[22]

So rather than worrying about how we're supposed to establish that an artist's immorality affects how we *ought* to respond to their work, the descriptive approach offers a route that avoids normative matters altogether. Forget how we ought to respond!

On the descriptive approach, if knowledge of an artist's immoral actions *in fact* makes us resistant to engaging with their work, then that seems to make the work less successful in achieving its aims. If knowing about Woody Allen's relationship with Soon-Yi Previn makes you resistant to engaging with *Manhattan*, or even just distracts you from focusing on the film, then it seems like aspects of his moral character have introduced a roadblock to the artistic success of the film. Notice that the descriptive approach may seem as if it can avoid questions about the relevance of the artist's biography to their artwork as well. If knowing that a painting is by Hitler makes you turn away in disgust, even if the painting is an anodyne cityscape, then it seems to follow that there's an artistic failure in that case, too.

However, by shifting to questions about how audiences actually do respond rather than how they ought to, the descriptive approach flounders and cannot provide an adequate explanation of why the moral flaws of an artist can result in aesthetic flaws in their work. It's actually not so clear that the descriptive approach can adequately explain why your response to the artist's moral misdeeds is relevant to their artwork. If the artist's immoral character prevents you from engaging with their work, that's bad for the artist in some respect, but it's not a failure of the work itself, even when it does reflect the work's content. After all, nothing about the source of your resistance is found in the work itself. For comparison, consider a case in which you're personally acquainted with an artist, and they've always just rubbed you the wrong way. That might make you more resistant to engaging with their artwork, but that doesn't seem like a plausible instance of artistic failure: the artwork doesn't somehow become less successful because

of your personal beef with the artist. Or to press the point further, you might end up being resistant to a play or movie because an actor's face reminds you of a bully who tormented you in second grade.[23] Unfortunate, but not an aesthetic flaw of the work. So, what could make the moral misdeeds of the artist any different?

Even if we think this problem can be overcome, the descriptive approach faces yet another challenge beyond the one about relevance. According to this approach in its original context, moral flaws can be artistic flaws if they inhibit engagement with the artwork. But what if they just don't? Because the descriptive approach is, well, *descriptive* and not normative, it doesn't have the resources to explain why people *ought not* respond in a certain way to a morally flawed work if it doesn't actually get in the way of their imaginative immersion. The same goes when we apply this approach to the case of artists. If it happens that no one is influenced by the artist's misdeeds, then we don't have anything left to say about that. Oh well! Turns out no one cares. But you might protest, it shouldn't matter that the audience members are a bunch of thoughtless goons who are happy to ignore an artist's egregious immorality! They *should* care, even if they don't. If you're persuaded by that line of thinking, you'll be dissatisfied with the descriptive approach, as it doesn't appear to leave us with any resources to criticize the actual responses that people have to artistic immorality. So, it looks like it has a lot less bite than the normative approach.

We can add to this problem the further wrinkle that the moral misdeeds of the artist may not be widely known. One of the distinguishing features of recent events surrounding the moral flaws of famous artists has been the *revelation* of their immoral actions. Should we think that an artist's immorality makes their

work artistically worse from the start, even before we knew what we now know? Or does it somehow become worse once their misdeeds have come to light? The two approaches we have on the table have different ways of answering this question.

On the normative approach, the moral flaws of the artist give you reason not to respond to their work in the prescribed way: because you ought not respond in the way the work is asking you to, the work is to that extent artistically flawed. When the audience doesn't know about an artist's moral infractions, it can seem like these considerations can no longer apply. That's because we run up against a widely accepted moral principle: ought implies can. When we claim that a person ought to do something, it has to be possible for them to do it; otherwise, our prescription is at best irrelevant, and at worst nonsensical. To say that we ought not respond to an artwork in a particular way because of the artist's immorality requires that it's possible to do so, and we can't take the artist's immorality into account if we don't know about it. Of course, we might happen to not engage fully with the work (maybe because we're distracted, or maybe because the work isn't very good), in which case we will have done what the normative approach claims we ought to do: but we won't have done it for the right reason. So, while there's a sense in which the artwork is already made worse on this argument because there's a moral reason not to respond in the prescribed way, that reason isn't actually available to us until the revelation of artistic immorality. And that seems like a solid answer: the moral and aesthetic flaws exist; we're just not in a position to respond to them yet.

The descriptive approach, on the other hand, presents a different set of considerations. Because on this approach the aesthetic

success of the work is hindered by the audience's actual responses to the immorality of the artist, the fact that the artist's misdeeds are unknown seems to inoculate their work from suffering this effect. If the audience doesn't know that Louis C. K. sexually harassed women, then it's not clear how this could have a negative effect on the audience's response to his work.

Noël Carroll, one of the philosophers who champions the descriptive approach, considers a puzzling case with a similar structure. I have so far presented the descriptive approach as if it depended solely on the actual responses of the audience. But Carroll introduces some flexibility to this requirement by suggesting that the argument need not always depend on the actual responses of audiences *now*. He writes: "But even where given audiences do not detect the moral flaws in question, the artwork may still be aesthetically flawed, since in those cases the moral flaws sit like time-bombs, ready to explode aesthetically once morally sensitive viewers, listeners and readers encounter them."[24] Carroll is of course focusing on the immoral perspectives taken up by the work itself, whereas we are applying this general framework to the immoral character of the artist, but the same kind of point applies. Even when the moral misdeeds of the artist are unknown to the audience, we might say that the artwork is already compromised, because the audience's response would be (and will be) affected by knowledge of the artist's immoral actions once they come to light. Recent revelations about artists' immoral actions do have the feel of the ticking time-bomb that Carroll describes. This approach allows us to avoid the weirdness of saying that the artwork somehow suddenly becomes worse once the artist's moral character is revealed—that it would be OK before a bombshell news story was

published, for example, but problematic once it's gone to press. Looking at things this way, the artwork has always been compromised, even if the flaw was not yet known. It also gives audience members another reason to want to know about the moral flaws of the artist: they otherwise may be unwittingly appreciating morally flawed works! (If true, this would be great news for tabloids and gossip blogs.)

But even if this move works when it comes to the moral flaws of the artwork itself, things get more complicated when we try to apply it to the case of the artist. The moral flaws of the artwork are there from the start, even if the audience is unaware of them.[25] But when it comes to the artist, the immoral action may well have followed the creation of the artwork—this is certainly the case when it comes to Woody Allen's most famous movies, for instance. According to Carroll, the artwork doesn't suddenly become worse when the audience can no longer engage properly with it: the work was flawed from the start. But we cannot make such a claim when it comes to artworks that predate the artist's misdeeds, because the moral flaw in question wasn't there from the start: it hadn't happened yet.

One way to respond to this worry would be to shift our attention from the specific actions of an artist to their general character. I have been speaking loosely so far, invoking the immoral actions of the artist and their immoral character interchangeably. But you might think that although particular actions reveal the immoral character of the artist, that immoral character has been there all along. So, we don't actually encounter the problem of concluding that the later actions of the artist somehow render their former work worse. What matters is the artist's character, and that is also

best viewed as a ticking time-bomb, detonated by their actions at a moment, but wired to go off all along.

There are at least a couple of problems with thinking along these lines, however. First, it seems to be tied to an idea of moral character that is curiously independent of what we actually do, as if the die is cast and we are fated to be either good or bad people; most of us don't actually think about moral character in that way. A different strand of commonplace thinking about morality suggests that we craft our moral character *through* our actions. To claim that an artist was somehow morally corrupt before they did anything wrong conflicts with this familiar way of thinking about our moral character. This approach also encounters a further hurdle in the case of artists with especially long careers. Even if you think it makes sense to question the moral character of a person before they've committed any immoral acts, such thinking can only extend so far through a person's life. For instance, to think that Michael Jackson's early work with The Jackson 5 was somehow *already* corrupted by his later alleged abuse of children as an adult strains credulity—and I'm not just saying that wishfully, as a Jackson 5 fan. There is no plausible sense in which child-MJ had a flawed moral character.

This entire line of thinking about when it is possible or fitting for an audience to have a certain response to an artist's immorality raises a different kind of problem. Why, you might ask, are we focusing exclusively on the audience's *response* to a work of art? To be sure, audience response is part of how we assess the aesthetic success of a work, but it's not the whole story. Many great works of art go unrecognized. Moreover, what really matters, you might think, is what the audience is responding *to*. Focusing too much

on their reception of the work is a distraction from what really matters. For instance, according to one influential way of thinking about the nature of art, artworks are fundamentally an expression of the artist's inner thoughts and feelings. If the artist is morally corrupt, then you might worry that that very corruption will be exuded in their work. If art puts us in touch with the artist's soul, so to speak, then it can potentially expose us to something rotten and twisted.[26]

This view, however, seems to depend on sorting artists into categories of saintly and sinister, and then assuming that this overarching moral character will have a corrupting influence on the artwork of the evil, no matter what they produce. After all, the claim that artwork contains the expressive essence of the artist should be true regardless of what the artist's work is about. But this again forces us back to accepting the idea that Hitler's watercolors contain some hidden darkness, and there's no clear reason to think that unless we just assume the central tenets of this expression theory. Moreover, sorting artists into categories of righteous and depraved is a fool's errand. People are complicated, and to hitch our understanding of how morality matters to art to such a simplistic understanding of human character is a dead end. We can put this point in the form of a dilemma: either people are wholly moral/immoral, or they're not. If they are, and taking Hitler as our sinner par excellence, then when coupled with the expression theory, we encounter the problem with Hitler's watercolors that we've been trying to avoid: the theory says they're somehow morally and aesthetically tainted, but that seems absurd. If people aren't simply good or bad, but complicated individuals who do good and bad things, then we need to explain why what

an artist expresses in their work *must* be linked with specifically good or bad aspects of their character. When an artist's work has no thematic relationship with their moral misdeeds, why think anything pertaining to those actions is expressed in the work? Plenty of R. Kelly songs have nothing to do with his exploitative behavior. Or imagine that Kelly just produced lyric-free atonal mood music. It's entirely unclear by what mechanism such artwork would express anything morally suspect, whatever Kelly's personal failings.

Finally, there's something important about the emphasis on audience response in the discussion here. Morality is fundamentally social: it's about how we relate to each other. To say that an action is wrong or a person is corrupt just is, among other things, to identify that action or that person as a target for justified moral disapproval. When you pair these features of morality with the fact that artistic engagement implies an audience as well (even if sometimes an audience of only one), then focusing on audience responses to features of artists and artworks seems wholly appropriate. The point isn't that the response is all that matters, but that an audience's response stands in a revealing relationship to the moral and aesthetic features of a work of art.

Even if all the problems discussed so far could be solved, and even if the audience is in fact resistant to an artwork because of an artist's moral flaws, there is yet another complication to consider. The way the descriptive approach originally bridges the ethical/aesthetic gap is by pointing out that the moral flaws of an artwork can get in the way of the work's ability to achieve its own artistic ends. But by introducing that kind of relationship between the moral and the aesthetic, it invites an intriguing notion. We often

think that an artist's ability to overcome artistic challenges is itself a mark of artistic quality and success. By linking the moral flaws of a work with the creation of an artistic hurdle, this approach suggests that the artist's ability to surmount that hurdle could itself be a kind of artistic achievement as well. So, it turns out that the descriptive approach opens the door to what philosophers call *immoralism*.[27]

According to immoralism, the moral flaws in an artwork can sometimes result in distinctive aesthetic successes because they present an artistic problem for the artist to solve. This argument is exemplified by the case of what philosopher A.W. Eaton (borrowing from Hume) calls "rough heroes," characters with egregious moral flaws that the artwork nevertheless invites us to identify with. Unlike an anti-hero, who has some moral flaws but is ultimately a good person (like Han Solo),[28] rough heroes are irredeemably flawed. Consider Hannibal Lecter in *Silence of the Lambs*. Hannibal is a cannibalistic serial killer who performs many morally heinous acts in the course of the film: at one point, he cuts off another man's face and wears it as a mask. You might suspect that an audience would be resistant to developing any kind of allegiance toward such a character.[29] And yet, in the closing scenes, the film essentially asks the audience to laugh along with a joke that Lecter makes about eating the psychologist Dr. Chilton, a character whom, despite his relative lack of moral misdeeds, the film somehow manages to portray as far less likeable than Lecter. And we're there for it! We're not repulsed by Lecter's joke, and the film doesn't expect us to be. We all share a wicked grin as Lecter strolls off in pursuit of his vengeance and his meal. Thus, according to immoralism, the film has achieved something artistically

by getting us to form an allegiance to Lecter. His depravity should raise our imaginative resistance, which would be an artistic flaw in the film: and yet the film overcomes that challenge, which is itself an artistic merit.

Does something similar happen when we consider the ethical criticism of artists rather than artworks? If we assume that an artist's moral flaws result in artistic flaws when they prevent the audience from engaging with the work, does that mean that artists who manage to maintain an engaged audience despite their moral flaws are even greater artists for it?

Imagine that *Silence of the Lambs* were actually directed by a cannibalistic serial killer, and this was widely known, or that Anthony Hopkins, who won an Oscar for his portrayal of Lecter, was himself a cannibalistic serial killer (apologies, Sir Anthony).[30] And imagine that nevertheless the film and the acting succeeded in getting the audience to develop an allegiance to Hannibal Lecter. That would indeed be remarkable, in some sense, but would it be a specifically artistic achievement?

If this case gives you pause, then it suggests we might need to reassess the idea that the moral features of the artist are relevant to the artistic success of their work on the descriptive approach. Admitting that the moral flaws of an artist can make their work worse because of its actual influence on audience response opens the door to the further possibility that those moral flaws might also make their work better. Unless we can offer a compelling explanation of why the latter case should be ruled out, we might rightly be resistant to accepting the former.

In addition to the worry about immoralism, there are further reasons why you might think that the moral flaws of an

artist could make their work better. We often turn to artwork for its moral insight, and you might think that access to certain novel perspectives on immorality requires an immoral character in turn. Even if it isn't necessary that an artist, for example, be a murderer to have insight into the nature of murder, we might think a morally questionable disposition could put an artist in a better position to engage with such terrain. And even if you're not moved by such a consideration, you might think that artistic genius will often require a peculiar character that invites the bucking of moral norms—although some take this too far, as die-hard apologists for the Woody Allens and Roman Polanskis of the world do. Celebrated artists have often been recluses, outsiders, and eccentrics. As critic Charles McGrath puts the point, "The cruel thing about art—of great art, anyway—is that it requires its practitioners to be wrapped up in themselves in a way that's a little inhuman."[31]

All of this may be true, but to say that a "little" inhumanity is the price we pay for great art will be cold comfort to those who have been the victims of that inhumanity. The discussion in this chapter has offered us some potential tools for explaining why the moral flaws of an artist might compromise the artistic success of their work. I've argued that we need the bite of the normative approach in order to identify the specific cases in which we can justifiably claim that the actions of the artist influence how we ought to interpret the meaning of their work, sometimes with consequences for its aesthetic success. Yet even if an artist's immoral character doesn't necessarily make their work artistically worse, we may still have reason not to engage with that work. According to one way of thinking, the reason we should

2 | COMPLICITY AND SOLIDARITY

IS IT WRONG TO ENJOY THE WORK OF IMMORAL ARTISTS?

I was in Budapest when Michael Jackson died. I was on a trip with friends and we were taking a break after a long day of exploring, flipping through the channels on a tiny TV, trying to find something that wasn't in Hungarian. We stumbled upon the BBC and heard the news. Walking through a public park that evening, we encountered clusters of people huddled among the trees, clutching candles and pictures of MJ while they cried and hugged. It no doubt indicates my own ignorance and provincialism (I was just out of college and hadn't traveled much), but I was shocked to see this spontaneous display of mourning for an American pop star outside the United States. I was obviously out of touch. Jackson's death was a global event.

Fast-forward 12 years and Michael Jackson is experiencing a very different moment. In 2019, the HBO documentary *Leaving Neverland* gave new life to charges of child abuse against the pop icon that, though egregious, had long been familiar—familiar enough that I remember uninspired jokes about Jackson's pedophilia from when I was in middle school. Jackson was even tried (and acquitted) for child molestation in 2005. But the #MeToo

moment set a new cultural context for the release of the documentary, and now those allegations have been taken more seriously by the broader public. People don't make jokes about Jackson's behavior anymore. Instead, they've been calling for radio stations to stop playing Jackson's music.

In Chapter 1, we considered the idea that the moral flaws of artists might make their work aesthetically worse. I argued that when an artist's personal actions change the meaning of their work, then it is possible that their immoral behavior can in fact damage the aesthetic quality of their work in turn. But I doubt anyone is calling for radio boycotts of Michael Jackson because they think his songs aren't good anymore. For one thing, it's difficult to see how allegations of child abuse against Jackson could plausibly change the meaning of most of his catalog (though there may be exceptions)—he was not like R. Kelly, bragging about his immoral behavior in the very lyrics of his chart-topping hits.[1] But even if it did change the meaning of his music, calling for the boycott of any artist's work because it's not good enough is absurd. Who does that? That's what the skip button is for. And if it's the radio you're worried about, we put up with all kinds of bad music on the radio. No, calls for the boycott of Jackson's music stem from a different place, one that is far removed from aesthetics: the worry is that it's just morally wrong for anyone to keep enjoying the work of an alleged child abuser, no matter how artistically accomplished it is.

We often hear people say that they especially don't want to provide *financial support* to immoral artists. While it can seem like you have little ability to punish rapists and abusers who occupy positions of power in society due to their artistic success, you might

think that the least you can do is stop giving those bad actors your money. If it's wrong to line the pockets of known abusers, no matter how great their art might be or how much you enjoy it, then you have a moral reason not to financially support them by paying for their work. Even for those who don't think you have an obligation to stop consuming the work of immoral artists, this economic argument at least seems reasonable. For instance, in an interview with National Public Radio, TV critic Emily Nussbaum defends the idea that it is her job to engage with such artwork, but she acknowledges the economic argument for refusing to do so: "My job is actually to respond to the art itself and find a way to do that. But I definitely understand the idea that, for instance, you don't want to fill Bill Cosby's coffers—that makes total sense to me."[2]

Lining their pockets, filling their coffers, feathering their nest: these are all ways of talking about how your financial contributions will *benefit* an immoral artist, and in turn why you have a reason not to do so in light of their moral transgressions. But while it may seem straightforward, this outcome-based thinking faces a host of challenges.

First, your financial support makes no morally significant difference to any moderately successful artist if we're thinking in terms of material benefits. While your dollar no doubt means something to the subway busker, your individual purchasing behavior will have no discernible effect on an artist with any name recognition. Whether we consider movie tickets, music festival passes, or album purchases, your contribution is simply too insignificant to matter. It's not that your purchase makes literally no difference: you may deprive an artist of a penny (or more likely a fraction of a penny).[3] The point is that it's not a difference that

matters morally. If the purpose of withholding your financial support from immoral artists is to have a material effect on them by not putting money in their pocket, or at least to signal your disapproval to them, then that outcome needs to be a live possibility. But when your decision not to patronize an artist deprives them of a figure that falls far short of a rounding error in their annual income, your action fails to impact them or even be noticeable. This problem is compounded by contemporary entertainment delivery platforms such as streaming services for music and movies. Because you pay a monthly subscription fee to Netflix or Hulu or Spotify (or all three), you're not even making a decision to give money directly to an immoral artist. Rather, your impact will be measured not in dollars and cents, but in clicks, views, and tiny nudges to algorithms that render your individual actions even further removed from direct financial support of a particular artist. Now, if everyone (or even a large group) all decided to stop patronizing an artist, that could have a substantial impact on their livelihood and send them a clear message. But you're not everyone—you're just you.

This is a familiar problem in moral theory. It arises in any case where a large group of people acting independently or in concert could make a substantial difference, but no individual person's actions seem to matter on their own. Global climate change is a serious problem, and we are often encouraged to take steps to mitigate it: turn off the lights, use less water, eat less meat, adjust your thermostat, bike to work. But the fact is that your individual decisions to change your environmental behavior are irrelevant in the grand scheme of things. While it would make a tremendous difference if lots of people became vegetarians, *your* decision to

become a vegetarian has no morally significant impact. So, we're faced with a puzzle. We want to encourage people to change their behavior, because a large group doing so will make a morally significant difference; but your individual decisions don't matter, so it doesn't seem wrong to just carry on as you did before.

Here's one way you might try to solve this puzzle. You might argue that, appearances to the contrary, your individual actions really do make a morally significant difference. For instance, the philosopher Avram Hiller has argued that if you look at the numbers carefully, joyriding in your SUV has a climate impact that promises to have the morally equivalent effect of ruining someone's afternoon.[4] How Hiller makes this calculation isn't relevant to our purposes here: the point is that if you can show that your individual behavior can have *some* morally significant impact, then we can salvage the idea that there's at least some moral significance to your purchasing behavior because of the impact that it makes. If you could ruin Woody Allen's afternoon by not buying a DVD of *Manhattan*, you might think that's a perfectly respectable way to stick it to him and is therefore the right thing to do.

Unfortunately, it's highly unlikely that the numbers will play out that way in the case of purchasing albums and movie tickets. Hiller's calculations about climate change involve weighing your tiny individual contribution against the massive scale of the harm caused: while immoral artists can commit horrifying wrongs, they don't do so on a massive scale. But more important, when it comes to immoral artists, Hiller's approach makes the morally right action subject to complex moral mathematics in a way that can seem arbitrary and puzzling: rather than connecting the ethics of our response directly to the artist's immoral action, it links

the question of what you ought to do to the convoluted causal networks that stand between you and the artist. If you have a moral reason not to buy an artist's work, you would expect that to depend centrally on what the artist did, not on whether it happens to be the case that you have enough individual power to make them feel the force of your purchasing decision. It also has the bizarre implication that the more successful an artist is, and hence the less significance to them your individual behavior has, the less likely it is that you would have a moral reason to boycott their work. But, you might think, it's precisely the most successful immoral artists, the ones who are most clearly taking advantage of their power and celebrity to get away with harming others, whom we should care most about taking a stand against! An approach that focuses on making a material impact on immoral artists through exercising your purchasing power doesn't seem to stand a chance of achieving that goal.

Moreover, pinning our moral thinking about engaging with the work of immoral artists to the impact our decision might have on the artist will be undermined in cases where the artist is no longer living. Assuming the dead cannot be harmed (because they're, you know, dead), then outcome-based thinking won't apply to these artists.[5] Whoever profits from the sale of Michael Jackson's music now, it isn't Michael Jackson. So, if you think there's something wrong with playing "Thriller" at your wedding, you'll need to explain it some other way.

Finally, the outcome-based approach focuses specifically on your purchasing power (or lack thereof) as a tool for supporting or withdrawing support from artists. But popping in your old DVD of *Manhattan* (if you still even have a DVD player) can't have any

effect on Woody Allen one way or another. So, if you think there's something objectionable about continuing to consume the work of immoral artists in cases where this consumption is distinct from buying movie tickets or some other financial transaction that benefits the artist, you'll again need to find a different explanation for why that might be.[6]

All three of these concerns are rooted in the same problem: they have to do with the lack of impact your individual action will or can have on successful artists. So, if we want to explain why it could be wrong to engage with the work of immoral artists, we would do well to look beyond the impact of our individual actions on the artist.

A different approach is to explain why your action can be morally significant even when we just assume that your individual contribution makes *no* difference to whether any particular result comes about.[7] Imagine you're back in middle school and you see a big group bullying another kid on the playground. You don't have the social clout to stop them (you get bullied yourself sometimes), and there are already enough bullies taking a run at the kid that it will make no difference if you join in. It might even help you avoid future bullying. So, you decide to taunt away with the rest of them. I'm hoping you will join me in judging that this is a bad thing to do—the fact that your action makes no difference to the suffering of the bullied kid doesn't make it morally OK for you to join in the bullying. But if your actions don't make a difference, how do we explain their wrongness?[8]

Fortunately, we have moral concepts at our disposal that capture just such a situation. One useful notion is the idea of *complicity*. To be complicit in a wrong is to share moral responsibility for

it, even if you are not the primary wrongdoer. So, for instance, if you see your neighbor's house being burgled and could easily alert them, but you simply can't be bothered, we might say that you are complicit in the harm to your neighbor.

Now, you may still think that the wrong in question here depends on your ability to make a difference by helping to stop the burglary. The philosopher Adrienne Martin notes that more complex cases of complicity such as buying factory-farmed meat (or in our case, contributing money to an immoral artist) are made so vexing because they combine two different features. On the one hand, if it's wrong to engage in such consumer behavior, it's because you are an accomplice to someone else's wrong: you're not the one who abused children, it was Michael Jackson (allegedly). On the other hand, as we've already seen, your individual contribution to any reasonably successful artist makes no difference: it doesn't matter whether *you* buy tickets to the next Woody Allen movie or not. As Martin memorably puts it, complex cases like these are akin to "contributing to an already flush collective fund to hire an assassin."[9] It's the assassin who does the killing, not you, and if the Kickstarter campaign has already crossed the threshold for the hit to occur, then your contribution doesn't make a difference to whether the assassin is hired. No harm, no foul, right? And yet, you're likely to think there's something deeply wrong with making extraneous donations to a Kickstarter to "hire a house painter."

Martin suggests that the key to understanding complicity in these cases is the notion of *adopting a role*. For the consumer of factory-farmed meat, "she willingly participates as a member of a consumer group that has the function of signaling demand."[10] In the case of paying for the work of immoral artists, it seems like

something similar is happening. Here, we might think about it in terms of fandom. When you adopt the role of Woody Allen fan, you also willingly participate as a member of a consumer group that has the function of signaling demand, and one thing that signal could express is that demand for Allen's films should take precedence over moral concerns with his personal behavior. You, of course, can't signal that through your actions alone, but fans as a group could. The idea is that if the group as a whole is doing something wrong, then self-identifying as a member of that group should be morally questionable, even if your individual contribution makes no difference. Claiming that *your* actions don't matter one way or another doesn't make it OK to join the Ku Klux Klan. You should not adopt the role of KKK member, and being a card-carrying member makes you complicit in the wrongs of the group, even if all you ever do is carry the card.

Of course, the point is not that being a Woody Allen fan is morally comparable to being a KKK member. Rather, this is just a model for understanding how identifying as a fan of an immoral artist might make you subject to justified charges of complicity. When we accuse someone of being complicit by adopting a role, it's because the role that they adopt is being a member of a group that causes harm. This allows us to see that not all charges of complicity are equal. The extent to which the KKK as a group causes harm is manifest; the sense in which Woody Allen fans as a group cause harm is much more tenuous.

When people accuse fans of being complicit in the wrongful actions of the artists they love, they often act as if being a fan makes you complicit in an artist's *past* bad deeds, as if being a Woody Allen fan makes you complicit in his alleged sexual abuse

of his daughter, for instance. But now that we have a clearer picture of what it means to be complicit by adopting a role, it likewise becomes clearer that this claim doesn't make much sense. In the case of an artist who is actively using his celebrity in order to prey on others, for instance, we might plausibly say that being a fan makes you complicit—the artist's celebrity is a function of having fans, and so the fans as a group may be thought to play a role in enabling his future immoral behavior. But when it comes to misdeeds that are widely agreed to be in the past, it's a lot less clear that being a fan involves complicity in the way I've described. For example, factory farms are causing pain and suffering to animals right now, and so being a consumer of factory-farmed meat involves moral complicity—you're part of a group that signals demand for the farms to continue causing harm. But imagine that a particular factory farming operation decides to abandon their old ways and transition to plant agriculture: is it wrong to be part of the consumer group that signals demand for their new veggie burgers? Does that make you complicit in their past wrongs? The point is that moral complicity seems to depend on the prospect of future wrongs. For some immoral artists, that's definitely a live concern. But when people object to engaging with the work of particular artists precisely because of their *past* immoral actions, it's not clear that complicity provides the proper framework for understanding what might make such consumer behavior wrongful.

When it comes to complicity, there is one further point worth stressing. Because we live in a radically unjust world of intensely complex interconnections and dependencies, the account of complicity I've laid out here has a disquieting implication—it turns out that we're complicit in a dizzying array of terrible things.

From sweatshop labor, to exploitation by financial institutions, to environmentally hazardous behavior, if our account of complicity depends only on knowingly adopting a role as a member of a group that signals demand, it will be extremely difficult to avoid complicity in all of the world's moral failings. Perhaps, then, the avoidance of complicity should be regarded less as an absolute moral obligation (like the obligation to avoid murder) and more like a domain where you are free to exercise some choice provided that you're making a reasonable effort to make things better (like the obligation to donate to charity).

This is what philosophers call an imperfect duty (shout-out to Kant). Even if we assume that you have a moral obligation to donate to charity, we don't tend to think that you have an obligation to donate to *all* charities or to donate *all* of your available assets, and there will always be more worthy causes that could benefit from your support than you are obligated (or able) to contribute to. Consequently, the selection of causes to support with your time and money seems to be a space where you have some freedom to exercise your autonomy and contribute to those causes that are most meaningful to you. Moreover, in doing so, you have the opportunity to express something about yourself, what we might call your moral personality.[11] The fact that you contribute your time and resources to supporting your local library, for instance, expresses something about your values that's different from what would be expressed by focusing your charitable attention on nature conservation. You may well care about both, but the fact that you choose the library indicates your moral priorities, at least at this point in time (maybe you'll focus on nature conservation next year). The point is, when the amount that you can

do is limited in the face of limitless opportunity to do good, you have the opportunity to express your moral personality through your choice: this will be especially so under circumstances where we assume that your action doesn't actually make a difference. Analogous to the way that adopting a role as a member of a consumer group might make you complicit in a morally condemnable practice, adopting a role as the supporter of a morally worthy pursuit expresses its moral significance. We might call this *solidarity*.

Solidarity is the sunny side of complicity. Like complicity, it doesn't require that we make an individual difference (though making an individual difference may well be particularly good, just as making an individual difference beyond being merely complicit would be particularly bad). But when we act in solidarity with a cause we express something about both the cause and our own moral values. These are familiar ideas that we find in actions like boycotts. When you refuse to buy Chick-fil-A due to the company's support of homophobic causes, you adopt a role as part of a group that signals a rejection of those values.[12] Your individual decision to forgo fried chicken sandwiches makes no difference (you're not going to hurt their bottom line on your own), but your solidarity with the cause has moral significance. Solidarity operates via the same mechanism as complicity, but the valence of your action is switched: it's a morally good way of making no difference, rather than a bad one.

So, in a world where we can't reasonably avoid complicity in everything that's morally condemnable, the causes that we express solidarity with take on heightened significance. You may decide that it's important to you to avoid complicity with immoral artists and pay careful attention to thinking about whose work you

should boycott, expressing solidarity with their victims. Or you might decide that your priority is avoiding complicity with factory farming. The point is this: if we admit that your ability to avoid complicity across the board is limited, and hence perfect complicity-avoidance is not morally required, then we can see how boycotting an immoral artist could be a good thing to do, but not wrong to fail to do. Just as I can admire those individuals who carefully and methodically avoid eating factory-farmed meat in all circumstances without thinking that I'm failing by focusing my moral attention elsewhere, I can respect those who take a principled stand against a particular immoral artist without thinking that everyone is morally required to do so. To be clear, the idea is not that we can meet all of our moral obligations this way; there will be much that we are morally required to do in order to effect change and fight against injustice. The point is that when we focus specifically on that sphere of our moral lives where it is a *given* that we make no difference, we have more moral flexibility than some assume. Not limitless flexibility to be sure (complicity with the KKK is definitely wrong), but complicity and solidarity don't seem to offer a decisive framework for thinking about consumer ethics, and even where applicable, they leave us significant moral latitude to decide what to do.

So far, the discussion has focused on how your consumer behavior relates to the actions of immoral artists themselves, either through the idea of providing them with direct financial support or through being complicit in their behavior. But once an artist's misdeeds are widely known, a new moral dimension to engaging with their artwork emerges. Their artwork can come to function as a *symbol* of particular kinds of moral transgressions,

and consuming it can have a particular expressive significance to other people, irrespective of what the artist might do in the future, and ultimately unrelated to the specificities of the artist's actions and their particular victims.

To see this, let's distinguish between private and public consumption. Private consumption is what you do on your own time in your own space. If listening to R. Kelly doesn't make you uncomfortable, and you're in a private space, then it's natural to think that there's nothing wrong with binge-watching *Trapped in the Closet*, Kelly's serialized video "hip hopera" (though there may be more to this story, as we'll see). By contrast, public consumption involves listening to an artist in a way that is conspicuous, perhaps even intentionally so. No one else is going to be affected if you like to do the "Thriller" dance in your living room: if you and your friends decide to perform it for a talent show, that's a different story. The difference is that by making your consumption of Michael Jackson's work public, your action can *mean something* to others. On the one extreme, you may have chosen to perform "Thriller" because you explicitly aim to be supporting Michael Jackson, perhaps because you think he's innocent, perhaps because you think his guilt shouldn't be relevant to our enjoyment of his music.[13] But even if you're just oblivious to the charges against Jackson or don't care about them, your decision to perform his music can still have the effect of signaling your support to the audience.

How can that be? Sometimes, the expressive significance of our actions is not set by intention, but by context, just as we saw in the discussion of artistic intention in Chapter 1. If you're at a potluck where you ask a stranger how many slices of pie they want, and the

stranger holds up their middle finger, that expresses something to you, even if the stranger only intended to let you know they want one slice of pie. They've insulted you, and perhaps wronged you, too. To be sure, it's not a major wrong, and it's an easy one for the stranger to make up for by apologizing, and explaining their intention, perhaps their ignorance of what it means to flip the bird. But in most places in the United States, at least, you might think someone is giving you the finger even if they don't intend to give you the finger, because of the social significance of that particular gesture. Likewise, even if you don't mean anything by it, blasting "Age Ain't Nothing but a Number" with your windows down might mean something to people on the street, even if it's not what you intend.

That's of course not to say that you should be *prohibited* from pumping R. Kelly in public, but you also shouldn't be surprised or indignant if some passersby aren't happy about it. We might say that doing so would at the least be insensitive, and perhaps even willfully antagonistic. If you think we should generally try to avoid being insensitive and antagonistic when the cost of doing so is low, you have good reason to rethink your song choice.

But, you might protest, the cost *isn't* low. You might think the music is really outstanding. Sometimes, being insensitive is justified if it's in pursuit of a good that swamps competing moral considerations. So, if you think an artwork is worth engaging with aesthetically, but you're hesitant about the expressive significance of performing or presenting it publicly, a promising route would be to attempt to counteract that negative expressive significance as best you can. In other words, try to find a way to communicate

that your public engagement with an artwork isn't aimed at condoning the immoral actions of the artist who made it.

Context matters a lot here. In some contexts, it's easier to cancel negative implications than in others. In particular, I'm thinking about the classroom, a context I'm partial to as a college professor. I sometimes ask students to read and discuss the work of philosophers who had clearly immoral views. For instance, Immanuel Kant was explicitly racist, and I am in turn explicit with my students about Kant's racism. But I think there is tremendous value in reflecting on Kant's work, much of which has nothing to do with his racist views and is arguably inconsistent with them. It's easy to make clear in the classroom that reading Kant does not express support for his racism, partially because the classroom is a context where I don't necessarily support the views of *any* work that I teach. By assigning a text, I signal to my students that there is something valuable to be found there, and that's consistent with there being repellent things to find in the text as well.

It's a lot less clear how you would make a similar move when it comes to your public art consumption. As we'll see in Chapter 3, there are ways to contextualize the work of immoral artists if you're in a position of authority (a curator, for instance), but individual public consumption of an immoral artist's work in a way that doesn't express support for their actions is going to be tricky, especially if the artist's misdeeds are a hot topic at the time. You can't drive around blasting R. Kelly on your stereo and yell to each individual person that you pass: "I do not condone R. Kelly's behavior! This song just slaps!" The important thing to see is that when the immoral actions of an artist become widely known, their actions will be something we are forced to contend with,

one way or another. There is a passage from philosopher Christine Korsgaard that helps illuminate this idea. She writes: "If I call out your name, I make you stop in your tracks. (If you love me, I make you come running.) Now you cannot proceed as you did before. Oh, you can proceed, all right, but not just as you did before. For now if you walk on, you will be ignoring me and slighting me."[14]

This is the position we find ourselves in when the morally grievous actions of famous artists become public knowledge. We *can* carry on engaging with their work, but we can't proceed *just as we did before*. The state of play has changed. Most worrisomely, carrying on as if nothing has changed can seem like a way of *ignoring* victims, as if the knowledge that one of your favorite artists is a serial abuser is irrelevant, completely swamped by the fact that you're into their art. Like the person who calls our name, morality has just called out to us, and it matters how we respond.

What does this call require? I don't think it necessarily requires giving up an immoral artist's work, or living your private life as if it were public, though perhaps this is generational. In my Philosophy of Art class, I was recently teaching a paper by the philosopher Thi Nguyen about aesthetic testimony, or what you can know about an artwork based just on what someone else tells you. In one part of the paper, he tries to help the reader see that choosing to hang a painting in your bedroom just because some expert told you it's great is a really weird thing to do, especially if you don't share that judgment about the painting. If you don't like the painting and can't imagine coming to appreciate it, it seems absurd to defer to the advice of an expert and hang it in your bedroom, right? A curator might reasonably make that choice, wanting to

provide access to the art that experts think is most rewarding, but the art in your bedroom is for *you*, experts be damned!

I was shocked to discover how resistant some of my students were to this idea. They seemed to have trouble *conceiving* of an aesthetic decision that was private, that was just for you. Now, they mostly live in college dorms, so I could see what they meant about your bedroom not really being a private space: you often have a roommate, people are coming in and out, you share photos of your room on Instagram, etc. So how about what you're listening to on your headphones? I asked. Surely it would be odd to keep listening to music that you hated and had no prospect of appreciating just because an expert told you it was good. But the thing is, for many of my students, even their listening decisions aren't private. Their Spotify activity is shared publicly, and their friends will even razz them over what's on their playlists. Perhaps the private/public distinction is collapsing under the weight of social media and readers from Gen Z will have different gut reactions here from Millennials, Xers, and Boomers. But I take it that there would be something forced and artificial about turning *all* of your private art consumption choices into public statements. The philosophers Matt Strohl and Mary Beth Willard poke fun at this idea, imaging a person who broadcasts all of their (otherwise private) woke art habits: "Hey, I just wanted to let everyone know that I closed my eyes when I walked past a Gauguin painting in the museum, because he was a horrible person." "Guess who just threw away his blu-ray of Roman Polanski's *Chinatown*? This guy!"[15]

As Strohl and Willard note, this seems to push us in the direction of seeking a kind of moral purity or sainthood in our aesthetic choices. But that kind of behavior can be exhausting, misguided,

and antithetical to other aspects of pursuing a flourishing life. In his recent Netflix special *Right Now*, Aziz Ansari (who, to be fair, has himself been accused of sexual misconduct) sends up this reigning culture of performative wokeness. "Nowadays, man, sometimes even when the stuff is racist, I'm like, 'Can we just talk about something else? I don't think we're going to fix it at this brunch.'"[16] In other words, it matters that you oppose racism, but not that you're always *talking* about your opposition to racism, especially if all you do is talk.

The concern here is one that philosophers Justin Tosi and Brandon Warmke have identified in their work on "moral grand-standing." Moral grandstanding, as they define it, is an effort to contribute to public moral discourse with the aim of demonstrating one's own moral respectability.[17] One of the moral objections to grandstanding that they raise focuses on the self-absorption of the grandstander. Grandstanders, as they put it, "turn their contributions to moral discourse into a vanity project."[18] We recently considered the concern that carrying on without in some way reckoning with the actions of immoral art is a way of ignoring victims. But if grandstanding is ultimately about promoting your own moral purity, then it's really just ignoring victims in a different way. It may treat their abuse as an occasion for a purportedly moral stand, but it becomes one that is not ultimately *about* the victims. This particular phenomenon is aptly characterized in Thi Nguyen and Bekka Williams's recent discussion of what they call "moral outrage porn."[19] They identify the way in which certain expressions of moral outrage (paradigmatically on social media) come to be used for personal gratification rather than proper moral aims. It's a way of instrumentalizing the performance of

concern in order to make yourself feel good rather than because taking a stand is the right thing to do.

So, what counts as standing in solidarity with victims rather than grandstanding about one's own moral purity? In other words, what does it ultimately mean to be an *ethical consumer of art*? One way of getting at an answer is to consider what the costs of grandstanding might be when it comes to the case of art specifically. I want to suggest that grandstanding about immoral artists can not only instrumentalize their victims, but it can also instrumentalize art itself by treating it as if it's *just* about morality. If there's anything distinctive about the world of art, it's that art occupies a space where questions of aesthetics can't simply take a back seat. To be sure, ethics and aesthetics can be intimately related to each other, as we explored in Chapter 1. But while it's plausible that ethical considerations involving both works and artists can bear on aesthetics under certain circumstance, that doesn't mean that we should apply some sort of moral litmus test to all of the art that we consume or reduce the value of art to its moral content alone.

Some people might think that art only matters instrumentally, that its significance to human life rests only on its ability to make us morally better people, or to communicate ineffable moral truths. But think about all the ways that art (and aesthetic considerations more broadly) shape your life. You listen to music, go to the movies, hang pictures on your walls, decide what to wear or how to style your hair: these are all decisions about art and aesthetics, and a lot of them don't seem to have much to do with our moral improvement as people or taking a moral or political stand. Again, that's not to say they *can't*: many of these very aesthetic and artistic choices can have important moral and political

significance. The oddness stems from thinking that they *must*, and that they're not worthwhile unless they're serving some morally significant end. Making our artistic and aesthetic lives subservient to our moral lives in that way doesn't mesh with people's typical aesthetic behavior, so we should pay careful attention to the consequences of a view that dictates we must do so on pain of acting immorally ourselves.

One especially misguided example of the impulse to focus on the moral to the exclusion of the aesthetic is found in some strands of popular art criticism. Every time a movie or a book with controversial moral content is released, there is a rush for commentators (particularly on social media, but in more august outlets as well) to condemn the morally questionable content without even pausing to engage with the aesthetic features of the work. For example, consider the controversy over the movie *Joker*, condemned by some for its supposed glorification of nihilistic violence—much of that debate played out among people who hadn't even seen the movie.[20] Similar moral outrage has confronted movies as varied as *Harriet*, *Richard Jewell*, and *Soul*. Often, the message is simply: don't watch this movie! But a purported critic whose aim is to warn you about the immoral content of an artwork is at best a ratings agent, and at worst a censor. Real criticism aims at understanding. Criticism may of course yield the conclusion that a work is not worth the audience's time, but that should ultimately be because of its aesthetic merits. To be sure, moral features can influence aesthetic features, but taking that relationship seriously is different from allowing moral considerations to completely eclipse aesthetic ones. Using art criticism just to tell people which works are morally bad is like using food criticism just to tell people which foods

are unhealthy. I know that pie is unhealthy! What I want to learn is whether the pie at that place is *worth it*.

To be clear, this is a different question from whether the suffering of an artist's victims is outweighed by the value of their artistic contributions. It would be ghastly to think, for instance, that Bill Cosby's history of serial sexual predation was simply *worth it* in order for us to have his shows and standup routines (imagine telling his victims that!). The question is about the moral cost of engaging with the work given that the harm has already occurred. We can make this distinction vivid by borrowing a case from Oscar Wilde. In Wilde's novel *The Picture of Dorian Gray*, the protagonist's vices are recorded as blemishes to his portrait while the man himself remains youthful and beautiful. Now, imagine that this case is real. Imagine that Gray's original portrait were unremarkable, but the horrifying version, a direct consequence of his immoral behavior, were a magnificent work of art. We could say that it would have been better had Gray not committed the acts that led to the creation of the portrait, even if that means the portrait's aesthetic value would be lost. But this is a separate question from how we ought to approach the portrait once it exists. Is it morally wrong to marvel at the portrait, even knowing as we do that its aesthetic success is a direct consequence of various abuses (blackmail, murder, etc.)? Some might protest that we necessarily signal endorsement of those vices by engaging with the portrait, but why think that? We are sophisticated beings. We can consistently condemn Gray's immorality while marveling at the artwork it produced, even if that artwork itself still makes us deeply uneasy.

This is in part because art is a place where we're allowed to be unsure, where ambiguity can be a virtue, and that includes

moral ambiguity. This is such a familiar idea that the AP English Literature exam has included an essay prompt directing the test-taker to write about a morally ambiguous character in literature—the College Board is not exactly known for its controversial takes. But that's precisely why things get tricky when we bring the moral misdeeds of artists into the frame: we don't have the safety that we have in worlds of fiction to explore moral ambiguity. When it comes to what artists actually do, there are real lives at stake, real victims. I don't want to oversell the separation between the world of art and the real world: art can certainly have an effect on what happens in the world, for ill or for good. But the attitudes that it's appropriate to adopt toward artwork are governed in part by the functions of art; the real world isn't set up to provide a protected sphere for interpretation in the way the world of art is.

While I think it's true that the moral flaws of an artwork can be aesthetically relevant, I'm a lot less inclined to *worry* about those flaws. Is there something weird about delighting in Hannibal Lecter's depraved genius? If there is, I don't want to be normal. The fictions of novels and films offer us a space to explore human darkness in relative safety.[21] I have no compunctions about declaring my love for *The Silence of the Lambs* despite the fact that the ethics of the film are deeply complex: on the contrary, that's one of the features I find so engaging about it. I've used the movie many times in class as a lens for discussing ethical criticism of art, and time and again students make brilliant observations about the movie's treatment of monstrosity, feminism, and transphobia, often disagreeing with each other. In a beautiful essay, Lyra D. Monteiro captures this exact phenomenon. She describes her first experience, early in college, of reading a book that gave her

the tools to critically interpret *Lawrence of Arabia*, a favorite film from her childhood. She writes: "This in-depth critique did nothing to shake my adoration of the film; instead, it allowed me to love the film harder. Which I really, truly did. I had no problem at all imagining that a film created by white British dudes in the 1960s was problematic on race and gender and sexuality. And also no problem adoring the film, because rather than in spite of its flaws."[22]

Monteiro's comments help to draw a contrast with the moralizing "critic" I described above. It feels like people who want us to stop watching movies and reading books with morally complex content must not really care much for art in the first place; that moral complexity is part of what makes art so irresistible. It's challenging, it's discomfiting, it invites return visits and alternative perspectives. The point isn't that we *must* love any and all morally challenging art. There are people whom I know, admire, and respect who like movies that are far more depraved than I can stomach, and that's OK. I can't bring myself to watch *Funny Games* or other films sometimes categorized as "torture porn": frankly, I'm afraid of them. But I don't think people who appreciate them are psychopaths.[23] I mean, sure, that's *possible*. There's always the chance that consumers will use art in an uncritical way, no more than a lens for focusing their own perverse attitudes. These are what TV critic Emily Nussbaum calls "bad fans."[24] But the problem in those cases is clearly the person, not the artwork. To be sure, lots of art is just bad, and bad art shot through with morally horrific content will be all the worse. The point is that the morally problematic content of a work *can be* part of what makes it fascinating and worth engaging with, not that it must be.

The lesson is that it matters what the morally objectionable content of an artwork is doing in the work, and this can offer guidance when it comes to enjoying the work of immoral *artists*, too. As discussed in the previous chapter, sometimes an artist's actions can bear on the interpretation of their work, and sometimes they stand quite apart from it. Consider the case of J. K. Rowling, the author of the *Harry Potter* series. Rowling has recently drawn the ire of fans for her misinformed and bigoted tweets about sex and gender that are discriminatory toward trans and gender-nonconforming people. How should Rowling's attitudes affect our engagement with the fictional world she created? This is a particularly pressing issue for people who grew up with and love the world of *Harry Potter*. I'll return to the question of our aesthetic loves in the final chapter of this book; here, I want to use this case to reflect on a slightly different question. Because, despite the fact that I've read every *Harry Potter* book and seen every *Harry Potter* movie, I really don't love *Harry Potter*. I don't even particularly like it (if we're talking about wizarding schools, I'm an Earthsea guy through and through). But I'm also a parent. I recently read the first *Harry Potter* book with my kid, followed by a screening of the movie. It was a hit! An adorable shirt depicting Hedwig carrying a Hogwarts admission letter followed as a birthday present. On the heels of Rowling's tweets, I'm feeling uncomfortable about all that. Most of the decisions we make about our art consumption are for ourselves, but those of us with young people in our lives also make those decisions on behalf of kids, shaping what they are exposed to and what they might fall in love with. Should I limit my kid's *Harry Potter* consumption because of some tweets by the author?

Daniel Radcliffe, the actor who played Harry Potter in the film adaptations of Rowling's books, released a statement responding to her tweets.[25] Here's the heart of it:

> I really hope that you don't entirely lose what was valuable in these stories to you. If these books taught you that love is the strongest force in the universe, capable of overcoming anything; if they taught you that strength is found in diversity, and that dogmatic ideas of pureness lead to the oppression of vulnerable groups; if you believe that a particular character is trans, nonbinary, or gender fluid, or that they are gay or bisexual; if you found anything in these stories that resonated with you and helped you at any time in your life— then that is between you and the book that you read, and it is sacred. And in my opinion nobody can touch that. It means to you what it means to you and I hope that these [Rowling's] comments will not taint that too much.

Radcliffe's statement is evocative of some ideas we were introduced to in the last chapter when we considered the intentional fallacy and the death of the author. There is ongoing debate in art criticism about how much we should defer to the author's biography or intentions in our interpretation of their work. Radcliffe's comments, though, raise a slightly different question. They're not really about the meaning of the work on its own terms, but rather, about the meaning of the work *for you*. Regardless of whether we think a work of art has a particular meaning or is more accurately interpreted in one way or another, these questions can be distinguished from the work's *personal meaning*. The personal meaning

of a work is shaped by the role it plays in our lives, and *we're* the authors of that. Now, the fact that the personal meaning of a work can come into conflict with new knowledge grounded in revelations about the work's author can be an unsettling emotional experience, one we'll return to in Chapter 4. My point for now is only that the questions we may justifiably ask about the meaning of a work and the expressive significance of engaging with it don't always touch what the work means *to us*. That can be a protected sphere, and perhaps one that we can actively protect for young people. There may be a time when I want to have a conversation with my child about J. K. Rowling and her views about trans and nonbinary people, but that time isn't when we're pretending to be Hermione Granger.

This point doesn't just bear on works people are already attached to, but also on those they haven't tried yet. To take a different case, I don't think the fact that Roald Dahl was openly anti-Semitic means that people shouldn't read his books to kids (or not read his adult short stories themselves). To be sure, some of his books also include problematic representations of various kinds (I'm looking at you, *Charlie and the Chocolate Factory*), but learning to read critically requires complex literature. I imagine deciding not to read *Fantastic Mr. Fox* to my child, and being asked why I made that choice. What would I say? That I don't want to provide my financial support to Dahl? He's no longer alive, and I own the book anyway. That I don't want to be complicit in his anti-Semitism? To think that reading *Fantastic Mr. Fox* to your kid renders you complicit in anti-Semitism makes a mockery of the very idea of complicity. Roald Dahl fans are not a group that causes harm, anti-Semitic or otherwise. If we want the idea

of complicity to do important moral work, it can't be so thin a notion as to include cases like this.

Sometimes when we are unable to offer compelling reasons in favor of a decision, it means we've hit moral bedrock. In those cases, we can evaluate the choice by taking it as given, generalizing from its truth, and considering the broader implications of such a principle. For example, to borrow a headline from a viral article of yesteryear, I don't know how to explain to you that you should care about other people.[26] Sure, I could engage in the philosophical exercise of trying to derive this truth from even more fundamental moral commitments, but I think it's about as fundamental as things get. And a world where people care about each other seems like a good world: that commitment coheres well with other moral principles that seem similarly fundamental.

In contrast, a world where we just automatically stop engaging with the artwork of artists who have morally bad beliefs? I don't want to live in that world! A world where we reject *Fantastic Mr. Fox* because of some abhorrent things Dahl said in interviews later in life? No thanks. I prefer a world where we are explicit that Dahl's views are abhorrent, a world where we don't gloss over that fact by putting him on a pedestal, but also one where we acknowledge the truth that a person with morally bad views can still be a brilliant writer. And unlike our other case of a fundamental principle (that we should care about other people), there's so much to lose in a world where we treat the boycott of immoral artists as moral bedrock. We would lose a tremendous amount of art, not because all artists are monsters, but because human beings are morally complex. As Tyler Malone puts it: "No artist is free of moral, social, and political imperfections. This is partially

because we're all ugly, messy beings, but it is also because moral, social, and political imperfections vary depending upon the person, place, time, and culture doing the judging."[27] The second part of Malone's comment suggests a level of relativism about morality that I don't endorse: for example, I think the transatlantic slave trade was morally horrendous *at the time*, even if it was broadly endorsed by society—it's not the case that it was only morally wrong by today's standards. However, the point is still relevant here for a different reason. Even if we assume that morality is objective, different people in different times, places, and cultures will inevitably *get it wrong*, and it's their perceptions about morality (not necessarily the truth of the matter) that will need to drive decisions about which artists to spurn because of their beliefs or actions. So, not only would we lose a lot of art, we'd lose a lot of art for no good reason.

My point is not that there is no sense to be given to the notion of an ethical art consumer. Some commentators are dismissive of this very idea. They think that even asking questions about ethics is a mistake in the context of art.[28] When the 2019 Nobel Prize in Literature was awarded to Austrian writer Peter Handke, an apologist for Slobodan Malosevic's genocidal dictatorship in the former Yugoslavia, *New York Times* columnist Bret Stephens wrote: "His art deserves to be judged, or condemned, on its artistic merits *alone*" (emphasis added).[29] Like the formalists discussed in Chapter 1, such commentators maintain that art and morality are distinct domains. Resistance to the idea of an ethical consumer of art often seems to stem from the assumption that being an ethical consumer is primarily about what art you do or don't consume, as if it were a matter of putting only the ethically clean

art (or the art by morally pure artists) on the checkout counter and going along your merry way. But I think this is a mistake. In fact, I want to argue that being an ethical consumer of art will often *call for* consuming morally contentious art (or art by morally corrupt individuals). If we agree that being an ethical art consumer can't involve subordinating the aesthetic value of a work to moral concerns, then that suggests you actually have good aesthetic reason to view artworks by morally controversial artists (not over other artworks, but assuming you were already inclined to do so), because there are important aesthetic questions at stake. Being an ethical art consumer isn't a matter of *what* art you consume, but rather, of *how* you engage with it.

Why can't you just defer to someone else's judgment about the aesthetic impact of an artist's immorality? I mentioned earlier that there is a puzzle about aesthetic testimony. So much of our knowledge comes from what other people tell us. When I tell you that Trenton is the capital of New Jersey, you now *know* that fact (at least so long as I'm reliable, which I assuredly am, because I grew up in the great state of New Jersey). But when I tell you that "Elastic Heart" is an awesome song, you don't come to know that in the same way. You know that *I* think the song is great, but it seems that in order to arrive at the conclusion that it's awesome, you need to listen to it yourself. This is what philosophers call the *acquaintance principle*: the idea that knowledge of the aesthetic features of an artwork actually requires experiencing the work for yourself.

If the acquaintance principle is true, then it applies to our thinking about ethical consumption of art. I might read a review that informs how I see the relationship between Woody Allen's

moral misdeeds and the plot of *Manhattan*, but until I see the movie for myself, I'm not in a position to know whether Allen's moral character actually has an aesthetic influence on the movie in the way the review claims.

Although the moral misdeeds of an artist can be aesthetically relevant to their artwork when they alter its meaning, it's not straightforward to determine whether those conditions are met in any particular case. Audience members might disagree. In particular, deciding whether an artwork transgresses in this way requires the exercise of *judgment,* and one important consequence of that conclusion is that you will need to experience the artwork in question in order to decide whether it is subject to that objection. Has the movie's quality been corrupted by the artist's moral misdeeds? You need to watch it to find out! Afterward, you might decide that the work is in fact aesthetically compromised. You might write a review arguing for that conclusion; you might tell a friend; you might never watch it again. But watching the movie in the first place isn't antithetical to being an ethical consumer of art: it's an essential aspect of what being an ethical consumer of art involves! It's how you take art seriously *as art*, and not just as a prop in broader moral or political battles, however important they may be.[30]

In sum, this means that I reject the suggestion that ethical consumerism is inappropriate or nonsensical, but I also reject the idea that it necessarily requires abstaining from certain artworks. To be clear, the point is not that everyone *must* engage with these artworks, and art consumers may have all manner of good reasons to refrain from doing so. For instance, you might reject viewing a particular artist's work because you want to express solidarity

with victims of his predatory behavior, or even the class of such victims. Imagine you have a friend who was the victim of child abuse, and you know that he is deeply upset about the allegations against Michael Jackson. You might decide in solidarity with your friend that you're not going to listen to Michael Jackson anymore, or at the very least, that you're not going to play Michael Jackson at your wedding, where your friend is your best man. But note that your reason for making this choice isn't primarily about Michael Jackson anymore. It's less a question of how to be an ethical consumer of art than it is a question about how to be a good friend. That there can be good reasons for you not to consume the work of an immoral artist doesn't entail that it's generally wrong for others to engage with that same work, and it's a mistake to simply assume that those who persist in engaging with the work of immoral artists are not ethically serious and conscientious consumers.

What we have seen so far is that the ethics of our individual consumer behavior regarding the work of immoral artists is complex. While there are cases in which charges of complicity might be plausible, they are limited. The broader ethical terrain of our relationship to immoral artists can generate a range of morally significant considerations against buying or engaging with their work, but these reasons are nuanced and contextual: nothing that would necessarily support a blanket prohibition against individuals buying, enjoying, or engaging with the work of any artist in particular. As we first saw in the discussion of complicity and solidarity, the decisions we face when it comes to the work of immoral artists present an opportunity to express something about our moral personality, about the kinds of issues that we are sufficiently invested in that we will make personal sacrifices in order

to take a stand, however small, in support of values that we hold dear, even when doing so makes no difference. But because it's our moral prerogative whether to do so, it's also a context in which we can decide that there are other values that trump whatever reasons there might be to eschew a particular artist's work. Among those values are aesthetic ones. As we saw, taking art seriously *as art* can call for engaging with morally dubious work so that you can make your own judgments about it, considering, among other things, the impact of an artist's immorality on their work's aesthetic worth.

Does this mean we have a responsibility to investigate the lives of artists whose work we plan to engage with? Responsibility is a strong word: it implies error if we don't live up to its demands. Some might think that we have a moral responsibility to inquire into the lives of artists in order to avoid complicity with their behavior, but again, complicity-avoidance is generally a moral option, not a moral requirement. Might we have an *aesthetic* responsibility to become knowledgeable about the moral lives of artists? After all, I've argued that insofar as the moral lives of artists can have a bearing on the aesthetic quality of their work, we can have a justified aesthetic interest in considering that relationship. But having a reason to reflect on the bearing of an artist's moral life on their work (especially when you're already aware of their misdeeds) doesn't entail a responsibility, even an aesthetic one, to go looking for skeletons in the closet of every artist whose work you encounter. There are all kinds of facts about an artist that can inform how you judge the aesthetic success of their art, including a range of non-moral features concerning their style, their influences, their intentions, the place and period they're working in,

etc. We have good aesthetic reason to pursue this knowledge, if it interests us. But just as you don't fail aesthetically if you prefer to wander an art museum without reading every bit of wall text, it's not incumbent upon you as an art consumer to bone up on every artist's biography. We err in simply ignoring widely known facts about an artist's immorality, but that doesn't mean we have to become the cops and detectives of the art world.

However, there are some approaches to the work of immoral artists that seem flatly inconsistent with this latter approach to ethical consumerism. Sometimes, there are calls for the work of immoral artists to be *canceled*, completely scrubbed from public consciousness. What should we think about such demands? We turn to this issue next.

3 | REFORMING THE ART WORLD

SHOULD IMMORAL ARTISTS BE "CANCELED"?

In 2018, comedian and TV actress Roseanne Barr posted a racist tweet about Valerie Jarrett, senior advisor to former US president Barack Obama. The incident occurred just months after the revival of Barr's popular sitcom, *Roseanne*. Her tweet was only the most recent of Barr's racist and offensive behavior and ABC swiftly canceled the show.[1]

More recently, the Hachette Book Group was set to publish Woody Allen's memoir, *Apropos of Nothing*. Set, that is, until a large group of Hachette employees staged a walkout in protest of its publication, stating that they stood in solidarity with Dylan Farrow and survivors of sexual assault.[2] Hachette ultimately dropped Allen's memoir (though it was soon published by another press).

These cases capture the shift in focus from the last chapter to the issues we will discuss here. In Chapter 2, we explored questions about your individual responsibilities: whether you have moral reason not to purchase or consume the work of immoral artists. But now we need to address a related set of questions that encircle those. As with many other matters of moral gravity, individuals

alone cannot and should not always bear the burden of moral action. Sometimes, the response to immorality needs to be collective or institutional. For instance, consider climate change mitigation. You might think it's all well and good for individuals to work toward reducing their personal carbon footprints, but that's not a replacement for institutional action that would facilitate our transition away from a carbon economy. If all we do to address climate change is improve our home composting habits, we would rightly be accused of rearranging deck chairs on the *Titanic*. We face analogous issues concerning individual versus institutional action when it comes to navigating the problem of unethical artists. Should the choice of whether to engage with the work of some immoral artists just be up to us, or are there cases where their work should no longer be played, displayed, or performed? Should it have been up to TV watchers to decide whether Roseanne Barr's comments would influence their decision to watch her show, or did ABC make the right move in canceling it?

Typically, when we say that something has been canceled, we're talking about a performance, event, exhibition, or show, as in "tomorrow night's concert at Freight and Salvage has been canceled," or "Fox idiotically canceled *Firefly* after only one season" (though showrunner Joss Whedon has since faced moral scrutiny as well). ABC's decision to cancel *Roseanne* is an example of literal cancelation, but to some viewers there's a sense in which canceling *Roseanne,* the show, constituted the cancelation of Roseanne Barr, the person—it was a public rebuke that ended her production of new work, at least at that network. But people are not events. What exactly does it mean to cancel a person? For a person to be canceled has, roughly, come to mean that they should be shunned,

ostracized, or not engaged with, though what exactly counts as being canceled in this metaphorical sense retains substantial ambiguity, as we'll see. A *Vox* analysis of the history of cancel culture suggests that this usage stems from a Wesley Snipes line in the movie *New Jack City*, before it bubbled up through various cultural touchstones to more common usage on Black Twitter and onward to the broader public.[3] In the arts, for an artist to be canceled is still, in the first place, literally for their planned shows, concerts, exhibitions, etc., to not occur, but now with broader implications for individual consumer behavior as well. "Canceled" artists are regarded as *those who shall not be listened to/watched/read/etc.* because of their immoral behavior, as if the media conglomerate of morality pulled their content. Some commentators feel that we have found ourselves in a cultural context primed to "cancel" artists in precisely this way, a context that has fittingly been dubbed "cancel culture."

Should immoral artists be canceled, either literally or metaphorically? Forgive me for making this philosophical move at the climax of our inquiry, but . . . that is the wrong question. We first need to ask what our goals and values are in responding to the actions of immoral artists, and then see whether the kinds of actions, consequences, attitudes, and relationships that "canceling" involves in any given case effectively achieve those aims. In other words, the answer will be highly dependent on context. That doesn't mean there won't be principled ways of thinking through particular cases, but it does mean that the process of answering the question in any case will be complex.

Imagine if an acquaintance rushed up to you on the sidewalk and said breathlessly: "I heard my friend did something terrible: I

should never speak to them again, right?" You'd be unlikely to just say, "Definitely!" or "No way!" Rather, you'd probably want to ask a lot of questions before making a judgment about what to do. What exactly did the friend do? How do you know about it? Have you spoken with them about it? What do you hope to achieve by cutting them out of your life? Are there any costs to shunning them that you might want to consider first? If it turns out your friend slowly poisoned their grandmother in order to gain a large inheritance, you might well be done with that person! If they said something unintentionally sexist, a different approach could be called for. Commentators often act as if cancel culture is simply good or bad, something to be criticized or supported, something that exists or doesn't—but cancel culture is too amorphous for that, a label that lumps together all kinds of rationales and approaches for responding to an immoral artist. Aiming to reject or endorse cancel culture wholesale is like trying to decide whether it's a good blanket policy to scrap a car if it doesn't start. First you need to get under the hood and diagnose the problem.

I don't think it's possible (or particularly interesting) to attempt to define the one true Cancel Culture™. As we'll see, it's a term that's often used in misleading ways, but it's also achieved such ubiquity in public discussion that it can't productively be ignored. My approach will be to point out some features of how I take cancel culture to operate in the arts in particular, without assuming I'm using the term in a comprehensive way that every reader would accept.

As I understand it, cancel culture in the arts is characterized by widespread dispositions to engage in automatic calls to boycott and ostracize artists based on their immoral actions or words.[4]

It is at its core concerned with labeling an artist as *anathema*. In a religious context, to declare someone anathema is to formally excommunicate them from the church. In an Old Testament precursor to this usage, however, something that is labeled anathema is an object intended for sacrificial destruction. These uses both derive from the Greek *anatithemi*, meaning "to set before (as an offering)." Each of these etymological facts captures an important dimension of cancel culture, both for its proponents and its detractors. Cancel culture is committed not just to literal cancelation of an artist's events, but metaphorical cancelation of the artist from our collective consciousness. In this way, it differs from call-out culture, which is more overtly aimed at public shaming. Cancel culture may often operate in a way that begins with call-outs as a tool, but cancel culture in the arts ultimately aims to erase rather than excoriate. Many discussions of cancel culture beyond the arts focus on what kinds of responses to objectionable speech are appropriate, with an emphasis on the ethics of public shaming—that's an important issue, but a separate one.

I've described cancel culture as involving *dispositions* to declare artists anathema because a disposition doesn't have to be active in order to exert an influence on our behavior—this is part of what makes it fair to talk about cancel *culture*, as opposed to just focusing on isolated efforts to cancel artists. To be disposed toward some action is *to be set up to be set off*. In metaphysics, philosophers refer to the *fragility* of a wine glass, for instance, as a disposition. If you rap the wine glass against the counter, it will break: that's what it means for it to be fragile. But note that the wine glass is fragile even if it never breaks, and its fragility exerts an influence on how we handle it—namely, with care. Behavioral dispositions

operate in a similar way. If you know someone who is disposed to get angry, you will likely feel pressure to tread lightly around them, even when they're not actively enraged.

This speaks to a concern that commentators have raised about cancel culture. Some worry that even when people aren't actively being shunned for their words or actions, the general social disposition to react with cancelation influences how people act. If the disposition toward cancelation is too sensitive, set up so that a thoughtless joke can be life-ending, it will dampen the public expression of ideas. It's of course difficult to evaluate how extensively free expression is actually dampened by cancel culture, but it's clear that many prominent thinkers *believe* that it's a real problem. A letter articulating these concerns was published online by *Harper's* on July 7, 2020, signed by a host of artists and writers from across the political spectrum.[5] The letter was a kind of intellectual chum, generating a feeding-frenzy of think-pieces about cancel culture. For every critic of cancel culture there is someone who thinks that a certain kind of reduction in public expression is entirely appropriate. People should take more care with their words, especially if what they have to say is racist, homophobic, sexist, ableist, etc. The now familiar point is that freedom of speech may allow you to spew racist vitriol under many circumstances, for example, but it doesn't provide you the shelter to do so without social cost.

This point leaves open, however, what kinds of social costs are appropriate under different circumstances. We can endorse the position that people should be held accountable for what they say without thinking that scorched earth is always the appropriate response. There's a significant difference between a bigot raining

slurs and a thoughtful person making a good-faith effort to artic-
ulate a view that you think is ultimately wrong, or even harm-
ful: cancel culture often seems to erase the differences between the
responses that these cases call for, so it's not hard to understand
why criticizing it has become fashionable. I don't think it will
be too controversial to claim that we should be wary about care-
lessly rendering people anathema, sacrifices offered up for public
destruction. If this is a real consequence of cancel culture, it's at
least one mark against it. But is this really how events play out in
cancel culture, and if they do, for whom?

The automatic and sacrificial nature of cancel culture is perhaps
best displayed in contexts where it targets everyday people rather
than famous artists. The canonical case has become the story of
Justine Sacco, who after tweeting a tasteless joke found herself the
target of an internet outrage mob and ultimately fired from her
job.[6] Similar instances abound. These cases illustrate cancel cul-
ture's inability to operate at an intensity that isn't turned up to 11,
which isn't really surprising: you can't partially erase someone—
it's all or nothing. Its advocates may want accountability, but
accountability should be modulated by a commitment to propor-
tionality. There's considerable space between holding someone
accountable for a bad joke and trying to get them fired. Moreover,
by abandoning a sense of proportionality, overzealous cancelers
unintentionally help to create an atmosphere where people who
are simply facing the reasonable consequences of their own bad
behavior can be portrayed as victims of an overzealous cancel
culture. During the congressional hearings in which President
Donald Trump was impeached for "incitement of insurrection"
following an armed attack on the US Capitol where five people

were killed, Representative Jim Jordan complained that the hearings were an instance of "cancel culture."[7] Life may come at you fast when you foment a violent coup attempt, but that doesn't mean you've been canceled!

However, you might reasonably think that the high profile of famous artists makes their case importantly different from cases such as Sacco's. We often talk about holding public figures to higher standards: you might think that the platform of famous artists bears directly on what qualifies as a proportional way of holding them accountable, even when we're just responding to their Twitter activity.

But even for those who consider canceling to be a justified way of punishing bad actors, it is important to think carefully about what people are aiming to achieve when they try to cancel an immoral artist. By comparison, theorists of punishment distinguish among a range of different aims that punishment might set out to achieve: not everyone who is pro-punishment wants the same thing. Among the ways of thinking about punishment are corrective, incapacitative, and retributive approaches. The corrective approach favors punishment that aims at changing an individual's future behavior. This can have a rehabilitative flavor (for individuals who have already acted wrongly) or a deterrent flavor (for those who have not necessarily acted wrongly but who might be dissuaded from doing so by fear of punishment). The incapacitative approach aims at preventing an individual from repeating an offense. Note that the corrective and incapacitative approaches adopt different attitudes toward an individual's moral agency. On the corrective approach, the goal is to encourage a person to make different choices. On the incapacitative approach, the goal is to

limit a person's options for choice. For example, whether being incarcerated will lead a person to make different choices in the future or not, it's difficult to rob a bank (for example) while in prison. Finally, the retributive approach aims to punish an individual simply because they deserve to suffer for their actions, no matter what effect that might have on their future behavior.[8]

This menu of approaches to the aims of punishment offers us some options for evaluating the appropriateness of cancelation—perhaps a quick guide that the Twitterati could consult before brandishing their digital pitchforks. Without yet making any judgments about which of these goals we should pursue, we can see that cancelation may be a better or worse method for achieving them in a particular case. For example, I don't think it's a coincidence that a significant portion of concerns about immoral artists have to do with sexual abuse and exploitation. It's often the case that artistic celebrity *enabled* the exploitation, and so there is an intimate link between the perpetrator's status as an artist and their immoral actions. These are also cases where there are typically specific, identifiable victims, which helps to distinguish them from moral criticism of artists' attitudes (e.g., their racism, sexism, homophobia, etc.). To be sure, racism, sexism, and homophobia have many victims, but it's typically harder to lay specific victims at the door of particular artists the way we can in cases of interpersonal abuse. Combining these considerations, we yield worries about ongoing exploitation of future victims. Sexual abusers are usually serial offenders. So, when it comes to artists who leverage their celebrity in order to engage in sexual exploitation, there seems to be a real sense in which we can prevent others from being victimized in the future by publicizing the predatory

than a larger societal injustice. Gaugin's actions, in contrast, are part of the broad systemic injustice of colonialism, which continues to cause harm today. Moreover, Caravaggio's crime isn't obviously relevant to the interpretation of his work, whereas Gaugin's paintings have been criticized as the epitome of Western white men depicting "exotic" women of color primarily as objects of sexual desire, prompting not only criticism but also artistic responses, such as a series of paintings by artist Kehinde Wiley that aims to recapture the dignity and agency of Gaugin's Tahitian subjects.[11] While Caravaggio's paintings are sometimes violent, no one views them as a celebration of his own act of murder, nor is there any clear relationship between Caravaggio's murder and murders that take place today. Gaugin's paintings, on the other hand, are viewed by many as reveling in the very exercises of colonial power that allowed Gaugin to take sexual advantage of young girls in Tahiti. Because the effects of colonialism are still felt today, from racism to economic inequality to cultural exploitation, the fact that Gaugin is no longer alive doesn't stand as a barrier to activism surrounding his paintings in the way that it does when it comes to Caravaggio. Gaugin's paintings have a public meaning concerning colonialism that Caravaggio's lack in relation to murder.

That being said, we need to ask after the aims of attempting to cancel an artist like Gaugin. Does literally canceling exhibitions of his work, for example, promise to pay dividends in the fight against colonial oppression? The same can be asked of other deceased artists who have faced backlash primarily because of their views, rather than their actions. Consider the fascism of Céline, the anti-Semitism of Roald Dahl or Ezra Pound, the racism of H. P. Lovecraft or early Dr. Seuss. One might think that

opposing engagement with the work of these artists is part and parcel with opposing the harmful ideologies they espoused.

But is it? And is this even what activists are pushing for? It's important to emphasize that media coverage about cancel culture often conflates "canceling" with a range of different positions that are united only in their desire to take seriously the artist's immorality, as opposed to ignoring it or sweeping it under the rug. For instance, you might expect that a *New York Times* article titled "Is It Time Gaugin Got Canceled?" would include the views of someone who wants to cancel Gaugin in at least one of the senses we've been exploring. But the article doesn't manage to actually track down anyone who is opposed to displaying Gaugin's work or thinks we shouldn't engage with it. The audio tour for the recent Gaugin exhibition at the National Gallery in London poses the question "Is it time to stop looking at Gaugin altogether?" and curators are quoted as being worried about boycotts, but the most vocal critic of Gaugin interviewed for the article, Ashley Remer, explicitly says: "I'm not saying take down the works: I'm saying lay it all bare about the whole person."[12] There may well be someone out there who is opposed to the display of Gaugin's paintings, but the idea that the dominant view among critics of Gaugin is that his paintings should be removed from museum walls seems more grounded in sensationalism than fact. It's a convenient bait and switch for those who are reluctant to take seriously the immoral behavior of famous artists: they can cry censorship or wring their hands about the emptying of galleries, rhetorical moves meant to garner sympathy for the status quo, when often what's being demanded is just transparent and explicit reckoning with the artist's immorality. If "canceling" an artist now just means

providing an opportunity for consumers to reflect on the relationship between the artist's life and their art, then the term is being used in a misleading way, one that conflates a host of radically different meanings.

Of course, it's in part the fact that there have actually been instances of cancelation, both literal and metaphorical, that have helped drive the public discussion to its predictable, polarized conclusion, such that an article purportedly about canceling an artist is ultimately just about taking his abuses seriously. Perhaps the most high-profile recent instance of literal cancelation in the world of visual art was the decision by the National Gallery of Art to "indefinitely postpone" their impending exhibition of the American portrait artist Chuck Close on the heels of accusations that he had sexually abused models who sat for him.[13] However, there is a straightforward way to explain why this was a thoughtful and appropriate decision rather than an instance of cancel culture run amok, and one that doesn't commit us to the idea that every artist who is subject to accusations of immoral behavior should have their art ripped from the walls. A special exhibition at the National Gallery of Art is not merely a way of displaying an artist's work: it is an *honor*. (Is displaying Gaugin's work an honor in the same way? We'll come back to this in a moment.) To honor someone is to identify them as someone we should admire.[14] In the thick of accusations of sexual misconduct, there are clear worries about identifying a predatory artist as someone to admire, even if we think that their artwork is influential and important. We have good reason to think carefully about what such a decision communicates, both to the public and to the victims of an artist's alleged misconduct. In Chapter 2, I explained that when public

accusations are made against an artist, they shape the meaning of how we carry on in light of that knowledge, the same way that there is significance to your decision to walk on after I've called out your name. To honor an artist at the same time that they are being accused of sexual abuse seems like a way of *ignoring* victims. As philosophers Alfred Archer and Benjamin Matheson put it: "In short, honoring immoral artists supports the expectations that people will not listen and, even if they do, they will not care, which encourages victims to remain silent."[15]

However, honoring an artist and engaging with their work can often be distinguished from one another, as we can see in the following case. H. P. Lovecraft, an early 20th-century writer, is widely lauded for his distinctive brand of "cosmic horror." But much of his work, including his iconic short story "The Call of Cthulu," employs aggressively racist imagery. For decades, winners of the World Fantasy Awards received a bust of a Lovecraft caricature as their prize (think of it as a creepy, bug-eyed Oscar for fantasy writing). However, due to increasing resistance from the fantasy community, use of the Lovecraft bust was retired in 2016. The decision to cease using the Lovecraft bust is consistent with thinking that Lovecraft's work is important, influential, and worth reading. To continue to offer the award with this bust would have been a decision to *honor* Lovecraft by using his visage. Honoring immoral artists makes them into living monuments, and like other monuments to immoral things, the best response is sometimes to knock them down. But that doesn't necessarily mean we shouldn't *read* Lovecraft. This is simpatico with a line of thought that I've been developing throughout this book: that the attitude we take toward artworks and artists is often more

morally important than whether we engage with them. And we can consistently affirm both that there are good reasons not to honor Lovecraft by turning him into an effigy of excellence in fantasy writing and also that there is value in critically engaging with his stories. Indeed, there may well be artistic *interest* in Lovecraft's racism, not as a feature to celebrate, but as a force that shaped his literary worldview. There are lessons to learn there, no doubt troubling ones, about the nature of fear and how it is influenced by a racist society—in fact, the recent HBO show *Lovecraft Country* explicitly tackles these very issues. Tyler Malone captures the general point in a moving essay about his difficult relationship with the actor John Wayne:

> Rather than recoil from an artist's grotesqueries and let them destroy otherwise interesting and nuanced work, or rather than hold an artist at arm's length and pretend there's an impenetrable wall that separates creator and creation, embracing the bramble of imperfections and idiosyncrasies of an artist tends to make the work prick with even more strangeness and complexity, mystery and negative capability. Not only is an artistic canon of saints untenable, but it's undesirable.[16]

Now, the Chuck Close case is in some ways trickier than the Lovecraft case. With Lovecraft, it's easy to distinguish between honoring the artist and making his work accessible. The copyright on Lovecraft's stories has expired: you can download the entirety of his corpus to your e-reader for free. Paintings are different, though. To see them (not digital facsimiles, but the actual

paintings) they need to be displayed *somewhere*. This is especially true for the work of an artist like Close, whose paintings are often made at monumental scale. But, you might think, having your art in a gallery or museum is *always* an honor! So, while deciding not to honor Lovecraft without limiting access to his work is fairly straightforward, the case of visual artists like Close presents additional challenges. In other ways, though, the Close case should be easier. Lovecraft's immoral views infect the content of his work (he is comparable to Gaugin in this way, in a different medium). Though Close's transgressions were bound up with his studio, they're not part of the content of his work in the same way—Close isn't criticized for racist or misogynistic representations in his paintings. Provided we can take steps to avoid the deification of the artist, it shouldn't be impossible for us to distinguish between displaying the work and celebrating its creator's misdeeds.

That being said, it doesn't mean that all of Close's work should remain on the walls. For instance, if models who have charged Close with abuse don't want portraits of themselves displayed, their wishes should be respected. In a similar case, Emily Ratajkowski has written a powerful essay about the publication and display of nude images taken by a photographer she has accused of sexual assault, accusations which have since been echoed by other women.[17] While the legal issues surrounding ownership of the images may be complex, publishers and galleries could take a moral stand by refusing to display those images. This would be a clear way of taking the accusations seriously, a place to draw a line.

As we've seen, the question "Can we separate the art from the artist?" follows discussions of artistic immorality like a shadow.

But our investigation so far suggests that this question will have different meanings in different contexts. When it comes to focusing on the art, I've argued that the ability of art consumers to ask and evaluate this question for themselves is a defining aspect of being an ethical art consumer. To what extent is the aesthetic quality of the work influenced by the personal life of the artist? But when we turn our attention to the artist, the question has a different meaning. Here, we confront whether the repercussions that an artist should justifiably face for their immoral behavior should necessarily apply to their artwork as well. Does rejecting Close's alleged behavior as a person require rejecting all of his artwork in turn?

One way of trying to get a grip on this question is to ask how we can effectively communicate to victims that we *do* hear them, that we *do* care. I've just suggested that one straightforward step would be to stop circulating images created by the subject's alleged abuser, but this is a very particular kind of case. The victims of immoral artists' behavior don't necessarily show up in the artist's work. Whatever our responsibility to victims' demands, would it ever require the complete elimination of an artist's work from public life? I'm skeptical. When it comes to influential artists, where would we even start? And how far would we go? Wesley Morris captures this worry well in his essay on *Finding Neverland*, the HBO documentary about Michael Jackson's alleged abuse of children. "Michael Jackson's music isn't a meal. It's more elemental than that. It's the salt, pepper, olive oil, and butter. His music is how you start. And the music made from that—that music is everywhere, too. Where would the cancelation begin?"[18] You can't excise the King of Pop from pop music.

It does seem that there are some cases where we would be justified in simply never displaying an individual's artwork. Consider Samuel Little, a serial killer who the FBI believes to be the deadliest in US history (he has confessed to 93 murders, and been linked by evidence to at least 50).[19] While incarcerated, Little has been making pastel sketches of his victims, many of whom remain unidentified, and the FBI has shared some of these sketches in the hopes of identifying those victims.[20] The sketches are, for lack of a better word, horrifying. Rows of anonymous pastel faces depicting women who were gratuitously slaughtered by the same hand that composed the portraits. Just seeing them makes my eyes fill with tears; I can't help it. If there were ever a collection of drawings that should *never* be publicly displayed, this is it.

But I find it hard to draw lessons from this case. Little is not, like our other cases, a famous artist who has been revealed as a predator; he is a predator who has taken up art. Many of the considerations that weigh against simply erasing the work of famous artists when they commit immoral acts (the influence, significance, appeal, achievement, value, etc. of their art) don't apply to Little. There are bountiful reasons never to mount a Samuel Little exhibition, and no costs in not doing so. Perhaps similar reasoning applies to former president George W. Bush's turn to painting portraits of soldiers injured in the disastrous war that he himself orchestrated.[21]

The features that make display of artwork in a museum or gallery seem like an honor can be turned on their heads, though, to communicate a different message. Publicity is not always an honor; indeed, many approaches to reckoning with immoral artists depend on the idea that it can also be a source of shame.

The philosopher Daniel Callcut, also reflecting on the case of Gaugin, puts it this way: "Fame is no longer a shield from moral scrutiny: it's a magnet for moral attention. The failings of famous artists are now examined and publicised to a degree far beyond the consideration paid to those who commit the same wrongs in ordinary life. The script, in this sense, has been flipped."[22]

I agree with Callcut up to a point, though whether we successfully channel the increased moral scrutiny of famous artists is crucial to whether the script has really been flipped. Taking a page from those who have pushed for better contextualization of Gaugin's work by providing discussion of his actions alongside his art, perhaps the work of artists (dead or alive) should not be canceled but rather accompanied by explicit confrontation with their behavior, especially when it is systematic and unambiguous, such as Gaugin's sexual exploitation. Chuck Close's monumental self-portraits could come to have a very different meaning if accompanied by details about the multiple charges of assault and abuse against him.

Would such an approach communicate that victims are heard, but ultimately dismissible? Would it express that the art is more important than an artist's abusive behavior? I don't think it has to. It can also communicate the complexity of the situation. It can say that the ability to produce important artwork does not make a person admirable. It can say that we will not ignore charges levied against famous artists simply because of their fame, but will ensure that the stories of victims are told and that the perpetrators are held accountable. The desire to extirpate an abusive artist from public life is an understandable response to their behavior, but that doesn't mean that any action short of erasure is a failure

to treat charges seriously. Indeed, there are ways in which such a response can take away some of our tools for holding abusers to account.

If the goal of publicizing an artist's bad behavior and calling for their cancelation is to achieve an outcome where fewer people engage with their artwork (and hence the artist's cultural capital is diminished), then it's going to be highly relevant whether these tactics are actually effective. Attempting to cancel an artist might be counterproductive. For instance, it appears that streaming of music by R. Kelly and Michael Jackson increased following the release of documentaries chronicling their alleged abuses (and not just a little: R. Kelly streaming activity increased 116 percent the day the finale of *Surviving R. Kelly* aired).[23] At least in the short term then, it seems that an interest specifically in *limiting* the cultural reach of artists isn't necessarily served by attempting to draw attention to their misdeeds.

I do think there's a potential silver lining to these data, though. In Chapter 2, I argued that an important task for the ethical art consumer is to evaluate an artist's work in light of knowledge about their immoral behavior. Does that knowledge affect the aesthetic success of their work, and if so, why? If more people are returning to the work of artists who are subject to moral criticism in order to reevaluate their opinion of the artwork, then that's actually an ethical success. Of course, this activity may be more implicit than explicit for many art consumers (after all, they haven't read this book yet!), but the point is that consistent or increased engagement with the work of an artist whose immoral behavior has recently been highlighted isn't necessarily a morally undesirable thing.

Moreover, this point draws attention to a moral cost of simply trying to decrease or limit consumer access to the work of an immoral artist. If I'm correct that the defining feature of an ethical art consumer is the ability to thoughtfully evaluate the relationship between an artist's immoral behavior and their art, then attempts to *prevent* people from consuming an artist's work will preclude them from doing this. Viewed in this light, they are attempts to deny art consumers opportunities to exercise their own moral agency. Whatever the moral benefits of curtailing the distribution of an immoral artist might be (and it's not clear that there usually are such benefits), this is a serious moral cost. Even if you think it would be a good outcome for streaming activity of R. Kelly and Michael Jackson to drop precipitously, you might also think it would be a much better outcome if consumers came to this decision on their own rather than having that content yanked from streaming platforms. The collective rejection of an artist by thousands of fans speaking as one would be a striking event; for some studio executive to be cowed into cutting access to an artist's catalog can feel like a hollow victory, and a paternalistic one to boot.

Or not. Perhaps the way I've framed the situation in the previous paragraphs overvalues the significance of opportunities for art consumers to employ their moral agency through choices about how they engage with artwork by immoral artists. If you think that the primary problem with predators in the art world is that those in positions of power continue to protect them and enable their abusive behavior, then calls for cancelation that effectively target these levers of power are achieving precisely what they aim to. This is where the difference between artists who wrong

through their actions as opposed to their words really starts to matter. The artists we've considered in this book so far fall into roughly two categories: predators and bigots. These categories are certainly not mutually exclusive, but they capture the general distinction between people like Kevin Spacey, who allegedly preyed on young men, and people like Morrissey, who has become increasingly vocal in his embrace of fascist politics, but to my knowledge has not been accused of physically abusing anyone.[24] It's not surprising that our responses to the predators and bigots of the art world should take different forms. When it comes to predators, we don't just want to signal that their behavior is wrong, we want to prevent it. If prevention is our goal, then cancelation seems like it could sometimes be effective and warranted. Kevin Spacey was decisively canceled. He was dropped from the final season of Netflix's *House of Cards*, a show he'd been headlining for years, and Ridley Scott, the director of the film *All the Money in the World*, decided to erase Spacey from the finished film by reshooting his scenes with actor Christopher Plummer in Spacey's stead.[25] It's harder to imagine Spacey easily leveraging his celebrity to prey on others after such a public downfall. But it's important to see that this response doesn't really have much to do with Spacey as an artist specifically; it has to do with his fame and the power that comes with it.

An office worker who takes advantage of their supervisory role to exploit a subordinate abuses their power. Depending on the nature of the abuse, they might rightly be subject to termination; but at the very least they should not continue to be placed in a position of power over others. Celebrities don't always have this kind of formalized power over others, but they do wield

considerable social power. Undercutting their future projects (as happened to Spacey) is a way of curtailing that social power. Even if we think these repercussions were entirely warranted, though, it's a lot less clear how the goal of preventing further predation would be furthered by some of the broader demands of metaphorical cancelation, such as refusing to watch old Spacey classics. To quote a line from Ludwig Wittgenstein: "A wheel that can be turned though nothing else moves with it is not part of the mechanism."[26] Not only is it less clear what limiting access to an artist's past work might achieve, it also comes with further costs. As Graham Daseler notes, if we ditch all of Woody Allen's movies, for example, we also lose some of the best performances by iconic actress Diane Keaton.[27] Especially for arts that are collaborative like film and television, the collateral loss from wholesale cancelation could be significant.

Even if some kinds of literal cancelation can be warranted in the case of predators, the case of bigots seems importantly different. We're not going to *prevent* racism, for example, by ending the careers of racist artists. Racism is a *systemic* problem: it's baked into our institutions; our social reality is shot through with it. By all means, we should discuss, critique, and object to the racist (or misogynistic, homophobic, etc.) views that people express, whether they are voiced by artists or not. But we're fooling ourselves if we think that ending the career of a comedian who makes a racist joke, for example, is going to prevent racism in the way that ending the career of a sexual predator promises to staunch their predatory behavior.

But if our goal in responding to bigots is instead just to express our disapproval, rather than implausibly aiming at prevention the

way we do with predators, that will inform the nature of a fitting response, and the goal of protesting an artist's bigotry is not necessarily served by the current operation of cancel culture. It's important that effective action target the correct levers of power. It's easy to get caught up in punishing a particular artist, for instance, and lose sight of the media executives who shape the popular art content that we see. This is a sense in which the sacrificial nature of cancel culture can actually serve the interests of those in positions of power in the art world. There are countless talented artists out there who never get a shot at the financial support and exposure enjoyed by the studio-backed artists we come to know. Too much attention paid to *ending* certain artists creates controversy and drums up attention; when it's not decisive, this can simply serve to promote the artist in question. People keep trying to cancel Dave Chappelle: it hasn't worked. Osita Nwanevu puts the point well:

> If we find ourselves moving dizzily from outrage to outrage from week to week, we should consider that being outrageous has never cost so little or earned professional contrarians and provocateurs so much. When they're not weeping into plates of hors d'oeuvres about Twitter, they may well be writing for the *Times* or *The Atlantic*, finishing up a forthcoming bestseller, or taking up a standing invitation to join Bill Maher on national television. Such is life under cancel culture. It is mostly good.[28]

Nwanevu's main point is that the *threat* of cancel culture, the target of so much public concern from artists and writers in positions of power, has effectively proven little threat to them

at all. However, because of cancel culture's obsessive focus with the individual artist, in the cases where it is effective, it offers an opportunity for those powerful parties in the art world to jump on the bandwagon of pillorying a particular artist without making changes to their own operations.[29] The philosopher Olúfẹ́mi O. Táíwò has helpfully described how "elite capture" can take place across the political spectrum, with identity politics as one of its casualties—an idea that is supposed to focus on advocacy on behalf of a vulnerable group can be exploited to ultimately serve the interests of those in power.[30] The internet outrage of cancel culture seems especially susceptible to elite capture. Because of its reliance on social media, cancel culture is part of the attention economy, and attention is a finite resource. When cancel culture directs our attention to the sacrificial destruction of particular individuals, it's easy enough for those in positions of power in the art world to acquiesce to the canceling of some representative artists without making any significant alterations to who wields power in their organizations or how decisions are made. As journalist Helen Lewis puts it: "Those with power inside institutions *love* splashy progressive gestures . . . because they help preserve their power."[31] Angry Twitter users gain some momentary satisfaction, but nothing actually changes.

The difficulty is that the drive behind cancel culture is not without a reasonable motivation. Ta-Nahesi Coates notes that the ability to cancel people is nothing new; it just used to be the prerogative of the powerful alone. As he puts it: "Any sober assessment of this history must conclude that the present objections to cancel culture are not so much concerned with the weapon, as the kind of people who now seek to wield it."[32] He emphasizes

this point by observing that the NFL effectively canceled Colin Kaepernick in response to his peaceful protests against the violence faced by Black Americans, though critics of cancel culture never seem to include this occurrence (and others like it) in their list of grievances. Or to take an old-timey case, what is the clichéd Hollywood threat "You'll never work in this town again!" but an exercise of the unilateral power to cancel? But though Coates highlights the double-standard at work in criticisms of cancel culture (a point shared by Nwanevu and others), he also notes that the democratization of the power to cancel via social media is "suboptimal." Though it's better that the people share in the ability to cancel than leaving it as the sole purview of the powerful, it would be preferable still if we had legitimate and trustworthy institutions that held bad actors accountable. Then no one would need to be subject to cancel cultures at all, either by the powerful or by the people.

It is remarkable that Bret Stephens, a commentator who is not exactly a political ally of Coates, also attributes the rise of cancel culture to institutional failure.[33] Though his diagnosis is much direr than Coates's, he likewise claims that the public has coopted roles that were formerly played by institutions, and that it is institutions that must rescue us. Stephens's vision of that future is characteristically conservative, conjuring images that evoke a return to old ways rather than institutional reform. But though we disagree about the roles that institutions ought to play, we share the notion that it is institutions that ultimately ought to play them.

When applied to an amorphous social entity like the art world, this raises a difficult question: What are the relevant accountable institutions that would allow us to avoid the suboptimal world

of crowd-driven cancel culture? The art world comprises a broad array of formal and informal institutions.[34] The formal institutions of the art world are as diverse as museums, galleries, publishing companies, art schools, media conglomerates, production studios, record labels, and magazines. When you consider many of the cases discussed in this book, Coates's analysis rings true: cancel culture stepped in because institutions failed to act. For every charge of abuse against an artist that has surfaced during the #MeToo movement, there have undoubtedly been a host of people in positions of power who knew and responded by covering up, obfuscating, or simply doing nothing.

The problem is that the unstructured public does not generally offer a reliable mechanism for accountability, so even when cancel culture gets it right, it doesn't help to change or build institutions that offer the kind of accountability that would help to prevent future abuses. Moreover, as discussed above, cancel culture offers the prospect of elite capture of social media outrage unaccompanied by institutional change. The problem, then, is not with critiquing or protesting the operations of the art world but with the particular aims and operation of cancel culture. Rather than focusing on the erasure of particular artists, we should protest for change in the institutions that control so much of the artistic content that we are exposed to, because that's what will help to build arts institutions that are accountable. This doesn't mean that even reformed institutions aiming to do better will always get it right. But cancel culture often gets it wrong, too, and with no mechanism for correction: cancelation is irrevocable. In a recent essay on the crowd-sourced delivery of "justice," the philosopher Regina Rini likens the internet to a "Big God," the kind familiar from

Abrahamic religions, that is all-knowing and ready to punish. She writes:

> There is no effective court of appeals in internet justice; sheepish messages rescinding an identification rarely get retweeted to anywhere near the audience of the thunderous accusation. That is why the internet is a Big God and not simply a dysfunctional simulacrum of criminal justice. Even the most poorly run legal system is, in theory, answerable to the reforming efforts of someone. But, like the grand deities of old, Big God Internet is accountable to no one.[35]

Rini's discussion focuses both on the severity of internet-fueled punishment and the error-prone way that crowd-sourced investigations attribute responsibility (often wrongly as much as rightly, it seems). When you combine Rini's comments with Nwanevu's observations about the general lack of negative impact cancel culture has had on famous artists, we're left with the unsettling conclusion that the costs of cancel culture have primarily been borne by everyday people, including aspiring artists without fame or fortune to fall back on.

In the case of artists, an additional problem looms large: whether the artist really deserves to be canceled at all. As we've seen, cancel culture generally fails to discriminate among different kinds of immorality, in particular, the difference between how to respond to a sexual predator versus how to respond to a morally objectionable statement. This failure becomes particularly apparent when we're dealing with cases of speech or expression that are morally ambiguous or unsettled. Indeed, cancel culture is most galling

when it comes for artists because of their moral views. As we discussed in Chapter 2, art is a place where we're supposed to be able to explore moral ambiguity and moral uncertainty: we can't preserve that aspect of its power by allowing the general public to function as a censor deciding which artists are allowed to speak, even when we think they sometimes get it right.

The following kind of case helps to illustrate the advantages of institutional reform over cancel culture. Sometimes, charges concerning the objectionable behavior of artists focus on the very act of artistic creation, even though the purported wrong is tied to facts that reside outside the boundaries of the artistic content itself. These include charges of selling out and cultural appropriation. The terrain of cultural appropriation is complex and would take another book to do justice to (I'll consider the case of selling out in the next chapter). Here, I just want to focus on one juncture where concerns about cultural appropriation intersect with cancel culture and the biography of the artist. These are cases of what is sometimes called "voice appropriation," where an author writes about, or from the perspective of, cultural communities to which they don't belong.

In one much-discussed case, aspiring YA author Kosoko Jackson was pressured to pull his debut novel *A Place for Wolves* due to Twitter backlash about its depiction of Albanian Muslims, a group to which Jackson does not belong.[36] Or consider the controversy over white artist Dana Schutz's painting of Emmett Till at the Whitney Biennial, or most recently, the backlash surrounding white author Jeanine Cummins's *American Dirt*, which was said to appropriate the stories of Mexican immigrants. In each of these cases, critics raised concerns about the content of

the artworks, but those concerns were typically informed by facts about the artist's identity. For many commentators, the artists in question didn't just create flawed works, they *acted wrongly* by creating those works in the first place.

As complex as it has sometimes been to sort out the proper response to artistic immorality in the cases we've considered so far, those cases have also tended to be relatively simple in one sense: the artist's moral transgression has been easy enough to grant. It's obviously wrong to be a predator or a bigot (though people of course disagree about what counts as bigotry). The question we faced was what to do about it. Here, however, we need to confront a different challenge first: The ethics of voice appropriation is extremely complicated, not to mention a relatively new source of moral concern.

Let's start with the problem, which is very real. The art world is plagued with issues surrounding representation. There has been a paucity of stories in popular media centering the lives and voices of marginalized people. When they are present, underrepresented people often appear as caricatures, stereotypes, or set pieces. I always think of the opening of Disney's *Lilo and Stitch* (after the amazing alien space chase, that is), where a row of Hawaiian dancers is *literally* just the same person over and over. It's clearly not incidental that the artists depicting marginalized people in these works don't belong to the relevant communities. While this mismatch doesn't ensure misrepresentation, it certainly doesn't help. Against the backdrop of these representation problems in both content and authorship, it's not surprising (or unreasonable) that the identity of artists has become a salient point in evaluating a work of art.

However, translating the lack of representation in popular art into a coherent plan of action to fix it presents a number of pitfalls. We cannot and should not aspire to a world where novelists and screenwriters only depict characters from their own communities. I don't think many critics of underrepresentation in the art world would intentionally recommend anything so extreme, but we need to be wary of approaches to questions of identity and representation that even inadvertently entail this conclusion. Focusing simply on who is "allowed" to represent whom is particularly risky. For one, there can be heated disagreement about who counts as a member of a particular community: for example, should an Indian American who has never traveled to India write stories that are set there? And even if we can sort out these questions about group membership, do we want to read stories or watch movies that contain only members of the communities that the artist belongs to? Should authors only write characters who share their gender identity, for example? These restrictions would be both unrealistic and aggressively limiting, especially when you remember how multi-faceted our identities are.

One way that critics wisely avoid the implication of a one-to-one correspondence between the identity of an author and the subjects they depict is by combining concerns about the author's identity in relation to their work with criticisms of the content of the work itself.[37] So, for example, many criticisms of Cummins's *American Dirt* didn't just assert that a white American woman shouldn't write about the Mexican immigrant experience but made more nuanced claims. They argued that Cummins didn't adequately educate herself about the communities she was depicting so as to avoid stereotypes and misrepresentations. They questioned why a

white American woman should be given the kind of publicity and financial remuneration for such a story when writers from the relevant communities are so underrepresented, and often underpaid, in publishing.[38] These criticisms *concern* Cummins's identity, but they don't *end* there.

It would also be a mistake to think these criticisms about representation only target white artists, those who have been privileged by the publishing industry (which, surprise, is 82 percent white).[39] For example, Kosoko Jackson is Black. Rebecca Roanhorse, an author of African American and Native heritage, has faced criticism because her novel *Trail of Lightning* was set in Diné (Navajo) land, a tribe she doesn't belong to.[40] If these underrepresented authors have become casualties of a critical lens meant to push back against underrepresentation in publishing, we might well question the principles of the approach. My aim here isn't to settle questions about voice appropriation and who should write about whom, but just to point out how *un*settled the questions are. To be sure, those are conversations that we should have.[41] But the uncertainty surrounding the ethics of voice appropriation should at least suggest that canceling is not the appropriate response to violations of its supposed norms. Literally canceling these artists would require assuming answers to the question of who should make art about whom, and then cementing those assumptions by rebuilding the art world in their image. That's a dangerous course to chart under conditions of moral uncertainty.

Though some of the responses to these artists may have fallen under the cancel culture umbrella, many others did not. Some of the best criticisms of *American Dirt,* for example, eschewed cancel culture's obsession with the artist and targeted the

industry instead. For example, David Bowles criticizes the publishing industry's annual practice of throwing so much weight behind a particular book. As he puts it: "Perhaps if it weren't for all the promotional hype, it [*American Dirt*] would have been easy to dismiss as a poorly executed work not worth paying attention to."[42] Or consider this remark from Shivana Sookdeo:

> To me, *American Dirt* didn't just happen because there's not enough, say, Latinx representation in the publishing workforce. . . . *American Dirt* happened because the veneer of progressivism remains valued far higher than the action of it. Without support for the marginalised already within publishing, from living wages to protection from backlash, you can't attract more. Without that growth of the workforce, you can't effectively safeguard against exploitative works. Without those safeguards, you make it even more inhospitable for diverse talent. Then you're back at square one publishing establishment, safe, whiter voices because the entire chain has been neglected.[43]

Sookdeo's comment about the "veneer of progressivism" is evocative of the worry about elite capture of cancel culture we discussed earlier. Moreover, it's notable that she doesn't focus on Cummins at all. The solution, from Sookdeo's perspective, is to change the industry.[44] Importantly, this is not just a matter of more diverse representation among the ranks of people working in publishing but about how those individuals are cultivated and supported. This point can be expanded to apply to the social institutions of the art world as a whole. For example,

arts funding in the United States continues to decline.[45] The museum world is rife with unpaid internships.[46] As Linda Nochlin famously argued in her essay "Why Have There Been No Great Women Artists?," our arts institutions have been set up to systematically favor the work of middle-class, white men.[47] There are countless ways that our arts institutions could be reformed to ensure systemic change that would uplift new voices and ensure more ethical practices, weeding out the predators and crafting a landscape where otherwise objectionable artists aren't worth canceling because there aren't so many thumbs on the scales pushing their work to the top.

It can be illuminating to consider this issue in comparison with no-platforming, the effort to prevent particular individuals from speaking at colleges and universities. The philosophers Robert Simpson and Amia Srinivasan observe that although no-platforming is often viewed through the lens of free speech, the fact that it concerns the activities of colleges and universities makes academic freedom a more apt framing for the issue.[48] They argue that one of the principles that characterizes academic freedom is a level of independence from outside influence, allowing experts to explore the best research and teaching in accordance with their expertise. They rightly note that all kinds of content are excluded from the university as unworthy of serious attention. A university's decision to deny a platform to some flat-earther is not a free-speech violation. Simpson and Srinivasan note that there will be hard cases where experts in the university disagree about what is or is not beyond the pale; the point is that no-platforming is not necessarily inconsistent with, and may indeed be necessary for, a commitment to academic freedom.

If you follow this line of reasoning, it's members of the university, not the general public, who are responsible for regulating who gets to speak in an academic setting—indeed, the fact that it's not up to the public is precisely the point. That's what protects the independence required for academic freedom. Now, there are differences between many art world institutions and academic ones, but there are also lessons about the art world and cancelation that we can learn from Simpson and Srinivasan's analysis. There are many individuals in positions of institutional power in the art world who have roles that are analogous to those filled by faculty in colleges and universities: editors, directors, publishers, critics, curators, etc., who make judgments about what art is worth bringing to the public. No one should be denied the opportunity to express themselves artistically, but no one is *entitled* to have their novel published either. There are of course disanalogies with academia, as well: in many contexts, these individuals will be making decisions based on judgments about what art they think will be profitable in addition to (or in lieu of) what art they think is good. But either way, whoever occupies these positions of institutional authority will play a pivotal role in determining the choices that are made at the institutional level, both about what art is supported and what artists are deemed acceptable to work with. If part of the problem in the art world is that those who are in positions of institutional power are being too permissive about working with predators or are giving short shrift to artists from diverse backgrounds, then we need to change how those institutions operate. We need to build institutions that will hold artists accountable in ways that will make cancel culture unnecessary and will promote change in a way that cancel culture hasn't been

coming mere hours after Roseanne's offending tweet. But reports suggest that the decisiveness of the move was spurred in part by Channing Dungey, president of ABC Entertainment and the first Black executive to helm a major television network.[50] The speed of the decision suggests that it might be a mistake to lay the decision at the door of cancel culture, and we should instead credit Dungey with making the kind of move that those in positions of institutional power should be considering in response to the bad actions of the artists they support, not due to fear of public backlash but because they want to craft institutions that uphold certain values, the same way the leaders of the National Gallery canceled Chuck Close's exhibition. When it comes to predators, we need institutional leaders who will firmly draw the line. When it comes to more complex ethical issues, such as those surrounding voice appropriation, an industry that elevates a wider range of voices would address worries about representation through means other than cancel culture. Professor Brittney Cooper makes a similar point about Iggy Azalea's appropriation of what Cooper terms "sonic Blackness." As much as she dislikes Azalea's music, she writes: "If she existed in hip hop at a moment when Black women could still get play, where it would take more than one hand to count all the mainstream Black women rap artists, I would have no problem."[51]

Nothing I've said against cancel culture should be interpreted as a general opposition to protest in the art world, or even to the use of social media as a protest tactic. Protest is an essential mechanism for seeking the kind of institutional change I've argued for, and social media can be an effective tool for facilitating such protest. For example, the #OscarsSoWhite social media campaign

was generally effective in drawing attention to lack of diversity in the film industry, and it seems to have spurred some initial efforts to better diversify membership in the Academy of Motion Picture Arts and Sciences. But notice that while this was a social media protest, it wasn't an instance of cancel culture. Rather, as the hashtag's creator April Reign put it: "More structural and systemic change must occur, not just within the Academy but Hollywood as a whole."[52]

I want to conclude this discussion by commenting briefly on a further effect that cancel culture can have on art consumers. As we've seen, cancel culture involves rendering an artist anathema. That has consequences for the behavior of others, too: when someone is anathema, they are meant to be ostracized. This can result in a trickle-down effect of cancel culture, where those who still choose to engage with the work of canceled artists end up canceled themselves. Unlike multi-millionaire artists who have proven impervious to being canceled, their fans seem more likely to suffer for their transgressions. The *New York Times* recently ran a story about how cancel culture operates among teenagers. In the opening vignette, a girl decides that a boy in her class should be "canceled" for unrepentantly playing R. Kelly in the classroom.[53] R. Kelly, recall, is an artist who has faced criticism because of his consistent exploitation of young girls. In Chapter 2, I acknowledge that fans should be cognizant of the meaning that their public art consumption choices can carry, but here, boycotting the artist results in *ostracizing* those who listen to him. The sins of the artists shall be visited upon their fans. Should they be?

I think this is another undesirable feature of how cancel culture works. As I've argued, there's substantial moral and aesthetic

value in allowing people the agency to evaluate the work of morally problematic artists for themselves. But say you decide that you want to stop consuming the art of a certain immoral artist. Would it be hypocritical if you didn't hold friends and family to drawing the same line? I don't think so. Even if you fervently believe that a particular artist's work should be verboten, there's a big difference between trying to persuade a friend or family member that they should stop watching *Annie Hall*, for instance, and shunning them if they don't agree. Compare this with the approach that people generally take to the ethics of food choice. Meat and dairy consumption is a serious moral issue: there are significant concerns about the impact of animal agriculture on both animal welfare and environmental health that everyone should consider carefully. Nevertheless, shunning people who eat cheese is not a common tactic that supporters of veganism adopt. Indeed, despite differences in their views, vegans, vegetarians, and omnivores generally seem capable of eating together around the same table, whereas cancel culture often encourages much harsher judgment concerning individuals' personal choices about art consumption.

Now, some might say that there's not *enough* friction between vegans and omnivores, and perhaps vegans should be more aggressive in holding omnivores to account for their food choices—cancel the omnivores! But I'm skeptical that this tactic would encourage more people to eschew animal products, and it's puzzling that anyone thinks it would be more successful when it comes to the art world. The philosopher Barret Emmerick considers what we ought to do when people whom we love espouse oppressive views (racist, sexist, homophobic, etc.). While one approach may be to disconnect from these people, Emmerick suggests that, when

it's safe to do so, other approaches might be morally preferable. In particular, he considers the idea of standing in solidarity with our loved ones in an attempt to positively influence their beliefs. "Part of what loving another requires," he writes, "is believing in their potential to grow, holding them to account when they fail, and expecting them to be better."[54] Emmerick's thinking here is premised on the idea that when we're in a personal relationship with someone, we are better positioned to influence their views and behavior by providing the kind of "affective friction" that will make it more difficult for them to retain their oppressive views. The thought seems to be that you're in a better position to make it *uncomfortable* for your racist uncle if you can be present and gently challenge his view, for example, rather than disappearing from his life and allowing him to retain those views without ever confronting resistance to them. The same point is applicable to people's art choices. Even if you really think it's *morally wrong* to listen to R. Kelly, canceling R. Kelly *fans* doesn't seem like a productive avenue for changing anyone's behavior. In an essay critiquing call-out culture, Loretta Ross puts the point well: "Similarly problematic is the 'cancel culture,' where people attempt to expunge anyone with whom they do not perfectly agree, rather than remain focused on those who profit from discrimination and injustice."[55] As she goes on to note, "Most public shaming is horizontal": it promotes avoidance of sensitive issues and does little or nothing to create change.

Cancelation is a blunt instrument. I've argued that there are cases in which the actions of predators can warrant literal cancelation, such as the National Gallery's decision to cancel their Chuck Close exhibition, but it remains difficult for me to see how

the all-encompassing nature of metaphorical cancelation could be called for. There are good reasons not to honor artists who do terrible things nor ignore their transgressions, acting as if the quality of their art should somehow function as an excuse for their behavior. But these approaches are different from an effort to excise an artist's corpus from the world. While we should be wary of honoring them, I don't think we should endeavor to live in a world where we just pretend artists like Michael Jackson or H. P. Lovecraft never existed. Complete erasure is not a way of taking someone seriously—certainly not when they're reporting abuse, but neither when they are the abuser. Indeed, this is a central tenet of the approach to transformative justice that many activists have been urging institutions to adopt as an alternative to punitive policing where we lock up offenders and forget about them. We can still value and appreciate the work of morally flawed artists, so long as we take those moral flaws seriously. Cancel culture is an understandable consequence of an overdue moral reckoning in the art world, but it is not ultimately the best method for pursuing the change we need.

4 | LOVE, TRUST, AND BETRAYAL

HOW SHOULD WE FEEL ABOUT
IMMORAL ARTISTS?

Reflecting on her long-standing love of *Edward Scissorhands* amid recent allegations of domestic violence against lead actor Johnny Depp, culture critic Constance Grady wrote: "I loved this movie. It made me feel all kinds of deep and profound teenage feelings, and those feelings were real and I could not unfeel them. But now, whenever I thought about Johnny Depp, I felt a deep and profound disgust, a moral outrage. That was a real feeling too, and I couldn't unfeel it either."[1]

In other chapters, we've discussed what we ought to do in response to the actions of immoral artists. But, for art lovers, a defining aspect of revelations about artists' immoral behavior is how it makes them *feel*. How do we sort through our often conflicting emotions about unethical artists in a way that doesn't simply leave us feeling divided against ourselves? How should we interpret the meaning of our feelings and how should these feelings shape our relationship with the arts?

Following centuries of stark differentiation between emotion and reason in the European philosophical tradition, many contemporary philosophers have argued that reason is often shaped

by emotion and that our emotions can themselves be subject to rational assessment. We see prime examples of this relationship in the arts. As you'll remember from Chapter 1, artworks often aim to elicit certain responses from the audience, including emotional ones, and we can assess whether a particular artwork successfully earns the response that it's aiming for. There are contexts in which the personal lives of artists can be relevant to this assessment, and so to the aesthetic quality of the work, but this is far from the only way that our feelings arise in grappling with artists' immorality. Emotion plays a pivotal role in our personal relationship with works of art, both those we love and those we despise. One emotional response that many art consumers find especially salient when it comes to immoral artists is *betrayal*. We see this in Grady's reflections on *Edward Scissorhands*. Though she doesn't name betrayal as the feeling she's experiencing, it's evoked by the combination of emotions she describes: the dynamic of her youthful love for the film being compromised by the later feelings of disgust stirred up by revelations about Depp's actions. Or consider this *Guardian* headline about Morrissey's embrace of far-right politics: "Bigmouth Strikes Again and Again: Why Morrissey Fans Feel So Betrayed."[2]

While feeling betrayed is a paradigmatic emotional response when we learn that a beloved artist has committed an immoral act or espoused a reviled cause, there is also something puzzling about it. Betrayal is an *intimate* emotion.[3] It's different from being just disappointed, angry, or frustrated. When you're betrayed, it's personal. We don't feel betrayed by the behavior of just any artist. If I learn that an artist whom I've never heard of has committed

a terrible injustice, I may well feel outraged but not betrayed. Betrayal presupposes a particular kind of involvement between the betrayed and the betrayer: characteristically, what is betrayed is our *trust* in another.

But how do we account for the cultivation of trust between a fan and an artist they've never met? It's not that we never trust strangers; we put our trust in strangers all the time. For instance, when you fall asleep on the train, you might trust the other passengers in your car not to rifle through your luggage or draw on your face. If you woke to find that your cash was gone and you're sporting a new Sharpie mustache, you might well feel that you've been betrayed, even though the other passengers are strangers. But your situation as fellow passengers has thrust you into a context where you are relying on the goodwill of others.[4] A kind of intimacy has been generated by the fact that you're all in the same boat, so to speak. We can appeal to these features of your situation in order to explain why it would make sense for you to feel betrayed in this case. By contrast, if your friend told you a story about having their bag stolen when they fell asleep on the train, betrayal doesn't seem like the right emotional response for *you* to feel. To be sure, you might empathize with your friend and feel anger on their behalf, but you don't seem to stand in the right relationship to the events to feel betrayed. After all, you weren't there on the train, putting your trust in the other passengers.

Politicians belong to another category of stranger that can paradigmatically betray us. We don't typically have a personal relationship with our representatives, and yet we can feel justified betrayal at their statements, votes, and actions. What

explains that? Politicians have platforms. They make explicit promises and commitments to their constituents about their plans and values. So, although we might not know them personally, we do stand in a trusting relationship with them. In fact, they *cultivate* our trust in order to secure our votes. When a politician abandons the platform they ran on, it makes sense for us to feel betrayed. They have violated our trust, at least if we were trusting (or gullible) enough to place it in them in the first place. After all, the fact that politicians endeavor to earn our trust doesn't mean that they succeed. A cynic with no expectation that a candidate will live up to their promises is unlikely to feel betrayed when, upon election, the new representative abandons the platform they campaigned on. The cynic might be angry, or they might just feel the sour satisfaction that their skepticism has been confirmed. But if there was no trust there to be violated, betrayal would be a strange emotional response to experience. This is also why you find yourself feeling enraged, perhaps, but not betrayed, by politicians in other districts or nations who violate principles that you value. If you're a US citizen who never had reason to trust the prime minister of Australia (for example), then you might find their immigration policy infuriating— but not a betrayal.

We're now in a better position to see why there's something potentially puzzling at play when we feel betrayed by artists we venerate—something that calls out for explanation. We don't trust them in the way we trust strangers on a train, and they don't make explicit commitments to us in the way that politicians do. So, why feel betrayed by artists who do bad things, rather than just feeling disappointed, frustrated, or angry?

One answer is that we love them. We love their art and we love them for making it. To borrow a phrase from the philosopher Nick Riggle, they are our aesthetic loves.[5]

Like interpersonal love, aesthetic love takes many forms. Our love for parents, siblings, friends, and romantic partners can vary in kind and character, and so too can the way that we love artists, ranging from affection to obsession, love that is healthy and love that is pathological. Sometimes we're *in* love with them; sometimes we love how they spirit us away from life's miseries—sometimes their art just makes us feel whole.

The teenage music acolyte is the paragon of artistic *devotion*. They plaster posters of rock stars across their walls, wear the t-shirts of their favorite bands, and if they're millennials (like me) quote just the right lyrics in their AIM away messages. Like other forms of devotion, this allegiance to certain artists expresses a kind of love, and like other forms of devotion, it embodies a set of ideals.[6] Teenagers express their aesthetic love in this public way because they think it means something, that it captures truths about themselves and what they stand for. But they're teenagers, so I'm sure they wouldn't admit to that.

While teenagers may be illustrative of an especially strong form of aesthetic love, many of us continue to relate to the arts in similar (if sometimes more subdued) ways throughout our lives. Among artists' many talents is the ability to express the otherwise ineffable. We often feel that our aesthetic loves have a unique ability to eloquently articulate or express our deepest values and commitments in ways that we, less artistically talented folk, are incapable of. We might give a poem to a crush to tell them how we feel, turn to a painting to process our own jumbled emotions, go

to a play and finally feel seen. The particular artists whom we love, whom we return to time and again, embody certain ideals that attract us to them, whether they concern an implicit conception of lyrical grace or an explicit statement of political protest. In turn, we see our attachment to these artists as expressing something about ourselves, about who we are and the ideals we aspire to.

So, when we become fans of a particular artist, come to value their work and identify with their art, we also end up placing our trust in them—we rely on their commitment to a set of artistic values, which can include aesthetic, moral, and political ideals. Following the philosopher Annette Baier's pioneering work, we can think of trust as involving, among other things, making ourselves *vulnerable* to another person. By trusting the strangers on the train, you make yourself vulnerable to having that trust betrayed or exploited. Likewise, when we trust artists to represent certain ideals, we leave ourselves vulnerable to having those values compromised. It is this background of love, trust, and vulnerability that sets the scene for the distinctive ways in which artists can betray us through their actions.

Consider this reflection from Claire Dederer's essay "What Do We Do with the Art of Monstrous Men" in the *Paris Review:*

I took the fucking of Soon-Yi as a terrible betrayal of me personally. When I was young, I *felt like* Woody Allen. I intuited or believed he represented me on-screen. He was me. This is one of the peculiar aspects of his genius—this ability to stand in for the audience. The identification was exacerbated by the seeming powerlessness of his usual on-screen persona: skinny as a kid, short as a kid, confused by

an uncaring, incomprehensible world. (Like Chaplin before him.) I felt closer to him than seems reasonable for a little girl to feel about a grown-up male filmmaker. In some mad way, I felt he *belonged* to me. I had always seen him as one of us, the powerless. Post-Soon-Yi, I saw him as a predator. My response wasn't logical; it was emotional.[7]

Dederer *identifies* with Allen, and is hence betrayed when that representation of herself lets her down by failing to uphold the ideals that she identifies with. Though she claims that this is an emotional as opposed to a logical reaction, this is a false dichotomy. Dederer's identification with Allen is common and reasonable: it's a ubiquitous aspect of how we engage with the arts. And that engagement, as is often the case with our emotional entanglements, has an internal logic to it. As Dederer recounts, there are reasons she identified with Allen: it wasn't random, or just some gut emotional appeal that defied explanation. He was the sympathetic underdog, and Dederer felt that way, too. But there are rules to being the sympathetic underdog. That role isn't compatible with also being a sexual predator. And so, because the reasons Dederer identified with Allen were overturned, that emotional engagement was likewise flipped on its head. Identifying with someone involves a kind of tacit trust that they will represent us in the ways our identification depends on. When that trust is betrayed, the identification crumbles. If that identification played an important role in our emotional lives, we're left unmoored.

Harvey Weinstein is the exception that proves the rule on this score. Weinstein's predatory behavior was truly monstrous, but the emotional response to revelations about Weinstein among

the general republic has been *fury* rather than *betrayal*. And that makes perfect sense based on what I've argued here. Who loves *a producer*? Producers are the banks of the art world. They are not the proper target of our aesthetic love, and in turn they fail to generate the kind of emotional attachments that would make betrayal an apt response to their moral transgressions.

No wonder, then, that if an object of our aesthetic love acts in ways that are inconsistent with the aesthetic, moral, or political sensibility that they cultivated through their art, we feel betrayed. By identifying with something outside of our control, we make ourselves vulnerable, just as we do when we love another person and trust them with the shared cultivation of a relationship. The problem when it comes to our love of artists is that the maintenance of the ideals we trust them with isn't really a shared project the way it is in a personal relationship—the artist is in complete control.

We see particularly stark, and sometimes pathological, examples of fans' identification with the artist when they take accusations against an artist as a call to arms. For example, some of Michael Jackson's most vocal fans have taken to the courts to defend his honor, going so far as to sue his accusers.[8] It's difficult to understand fans taking this kind of step without interpreting their relationship to Jackson through the lens of love and identification I've considered here. The philosopher Christine Korsgaard has argued that threats to our identity can make certain actions normative for us, actions we feel we must perform in order to preserve an identity that we value.[9] The accusations against Michael Jackson pose a threat to his advocates' identification with him— if they are diehard fans whose emotional lives are to some extent

organized around that identity, it's no wonder that they might feel they *must* defend him.

While the experience of betrayal in response to unethical artists is common and understandable (if not often taken to the lengths of the Jackson fans just described), that's not to say that it's necessary. My goal has been to explain why it can make sense to feel betrayal when details about an artist's beliefs or actions come to light, not to claim that we should all feel that way. You'll remember Daniel Radcliffe's reassurances to *Harry Potter* fans in the wake of J. K. Rowling's transphobic Twitter activity, which we saw in Chapter 2. Commenting on the moments from the books that spoke to fans, whatever they were, he wrote, "that is between you and the book that you read, and it is sacred. And in my opinion nobody can touch that. It means to you what it means to you." Caitlin Flanagan takes a similar line in her essay on Woody Allen's recent memoir. Like Dederer, she clearly loves Woody Allen, but her response to the charges against him is markedly different. She poses the question about whether we can still enjoy the work of immoral artists, and the answer comes quickly. "Of course we can," she writes, "because the movies don't really belong to Woody Allen any more than they do to you and me."[10] She goes on to recount how the question of whether it is right or wrong to watch Allen's movies doesn't really cross her mind when she turns them on; rather, what occupies her thoughts are the personal memories that are entangled with Allen's films. As she summarizes: "I'm a Woody Allen person, not because I disbelieve Dylan [Farrow, who has accused Allen of sexual abuse]—in fact, I believe her. I'm a Woody Allen person because his movies helped shape me, and I can't unsee them, the way I can't un-read *The Great Gatsby* or

un-hear 'Gimme Shelter.' These are things that informed my sensibilities. All of them are part of me."

Both Radcliffe's and Flanagan's comments embrace a similar view. They emphasize the personal meaning of artworks and contend that no one, not even the artist, can rupture that bond. The problem with this line, of course, is that it's just false, at least if we're reading it in a straightforward descriptive sense. The artist's actions *can* pollute our relationship with the work. This is what happened to Dederer when her identification with Allen was shattered. This is what happened to Grady, whose reflections on *Edward Scissorhands* began this chapter, when she said she couldn't unfeel her disgust and outrage toward Johnny Depp. *Couldn't.* Dederer and Grady might well wish that their relationships with the movies that they loved occupied the kind of protected personal sphere that Flanagan's did, or that Radcliffe wishes for the fans of *Harry Potter.* The claim that the artist's actions can't touch their art could perhaps be read charitably as more of a moral license to allow the work to remain separate, to be the cherished, formative experience that you want it to be. As I argued in Chapter 2, I'm friendly to that moral view: but it's cold comfort to the fan who finds their knowledge of the artist's actions intruding on their relationship with the work. And it also gives further sting to the force of the betrayal. We can read Radcliffe's comments normatively, urging that the bond between book and reader *should be* sacred. But alas, sacred things are often profaned. For those who fall in love with art and artists, there is much to be betrayed.

So far I've described the kind of emotional relationship we can develop with artists, and have used the idea of aesthetic love to explain why it can make sense for us to feel betrayed by an artist's

personal behavior. But our emotional lives are not confined to our minds: we express our emotions in action. A fitting emotional response can provide a justification for action that's different from those that we've considered in earlier chapters. When we feel a certain way, there are things it makes sense to do in light of those feelings. For instance, if you've been betrayed by a friend, you could be justified in telling them off, taking a break from their company, not going out of your way to help them out, etc. And the idea is that you might have reason to express your feelings in these ways quite apart from any of the other kinds of considerations we've discussed in previous chapters, such as whether it's the morally right thing to do. So, if we can provide a compelling account of the character and appropriateness of our emotional response to immoral artists, we'll have additional resources for explaining why certain actions (like refusing to consume their work anymore) might make sense. Returning to issues we discussed in Chapter 2, even if you agree that the financial impact of boycotting an artist is meaningless and you are unmoved by worries about complicity, you might nevertheless reject an artist's work as a way of expressing your justified feelings of betrayal.

But when an artist betrays us it doesn't follow that we *must* simply abandon their work, any more than we would just abandon a lifelong friend on the heels of a betrayal. To be sure, betrayal can and perhaps should reshape the character of our relationship, but to *end* a valuable relationship is the last resort, not the first.

You may remember from Chapter 3 Barret Emmerick's idea of standing in solidarity with our loved ones rather than abandoning them, even when they hold oppressive views. His idea is that by applying affective friction we might help shape their beliefs for the

better. Whether you agree with this proposal or not when it comes to our friends and family, you might think it straightforwardly won't apply to our relationships with artists, because those relationships are one-way. We may love certain artists, but they don't exactly love us back. To be sure, an artist might stand in an important kind of relationship with their fan base, but as a group, not as individuals. For the same reasons that your own personal boycott of an artist is an ineffectual way of sticking it to them (discussed at the beginning of Chapter 2), there doesn't seem to be a way for you as an individual to apply affective friction to a famous artist.

However, as with other social movements, you might think that influencing the behavior of beloved artists is something that fans can do *together*. In a video message expressing concerns about cancel culture, Kimberly Foster, the editor of the blog *For Harriet*, notes the difference between how we respond to the moral mistakes of others as individuals and how we respond as a society.[11] We can be permissive with each other about our individual responses, she claims, while working to foster a culture that is geared toward restorative justice rather than punishment. Combining this point with Emmerick's reflections, we might think that something fans can do, bound together as they are by their love of an artist, is try to stand in moral solidarity with the artist by creating affective friction in response to their views. They might help an artist see how a particular statement or position is in tension with the ideals that their fans take them to stand for. For example, *Harry Potter* fan sites such as The Leaky Cauldron and MuggleNet have issued statements against Rowling's commentary on gender identity— they may have hoped that the fact that they are avowed fans might mean something to Rowling (though so far, to no avail).[12] To be

sure, this is not a moral responsibility borne by an artist's fans, but it might be a project that they are already invested in because of their love for the artist and their work. I'm certainly not suggesting that standing in moral solidarity with sexual predators is the right move for fans; there can be a significant distance between artists who wrong in word versus deed. But as we saw in Chapter 3, part of the problem with cancel culture is that it often fails to recognize this distinction, grouping together artists who have committed violent crimes with those who have made misguided remarks. Fans can justifiably feel betrayed by both, but the responses called for can reasonably differ in kind. None of this should be taken to suggest that fans, in figuring out how to respond to their feelings of betrayal, shouldn't also be angry; but the appropriateness of our anger doesn't on its own determine what we should do.

Focusing on our feelings also gives us an opportunity to consider kinds of artistic betrayal that differ from most of the examples we've considered so far. Sometimes we feel betrayed by artists because of actions that concern the act of artistic creation itself. In particular, we can feel betrayed when artists sell out.[13] Although it is a criticism of an artist's art-making practice rather than an ethical criticism of their personal life, the charge of selling out has a clear moral cast to it—it's not just an aesthetic criticism. Artists who have sold out have acted wrongly in the eyes of their fans. Fans often disdain artists who sell out, rather than just being disappointed with their artwork and moving on to material they find more inspiring.

According to some ways of thinking about sellouts, it's hard to make sense of the moral dimension of the charge. For instance, in a recent paper the philosopher Claudia Mills argues that artists

lack artistic integrity, or in other words sell out, if they place "some other—competing, distracting, or corrupting—value over the value of the artwork itself in a way that violates his or her own artistic standards."[14] Mills emphasizes that it is a violation of the artist's own standards specifically that should serve as the relevant benchmark when it comes to judging whether they have sold out: her paradigmatic case concerns an artist who believes they have intentionally made their own work worse due to non-artistic motivations, such as fame or fortune.

But this way of thinking about artistic integrity makes it challenging to understand the moral dimension of selling out and the feelings of betrayal it can elicit. Consider that judgments about whether an artist has sold out are made from the third-person (or, more accusatorily, second-person) perspective, rather than the first-person perspective: while an artist could very well reflect on whether they themselves have sold out, selling out is typically a charge or accusation made against someone else. Viewed in that light, the idea that selling out is essentially concerned with the artist violating their own artistic standards appears puzzling. It's not that it's unheard of to criticize someone for failing to meet their own standards: this is essentially what we do when we call someone a hypocrite. But it's less clear why an artist who simply compromises their own artistic standards would be a subject for specifically moral criticism from a third party, and even less clear why it would constitute a betrayal. We need some interpersonal element to make sense of these second-personal moral emotions.

The reason we can feel betrayed when artists sell out is tied up with the trust we place in them. Thi Nguyen argues that, more specifically, we trust artists' *sincerity*—their commitment to

making artistic choices for aesthetic reasons as opposed to ulterior motives.[15] Nguyen explains that our ability to trust in artists' commitment to sincerity plays an important role in some of the social dimensions of artistic practice: for instance, when it comes to difficult art that takes substantial time and effort to interpret, our patience for it is facilitated by a trust that the artist is making a sincere attempt to create work that is guided by their aesthetic vision, and they're not just being lazy and imprecise. So, the sense of betrayal elicited by sellouts isn't just a matter of the artist compromising their own standards; more intimately, their compromising is a breach of the trust the audience placed in them.

When we consider the way that artists can come to represent aesthetic, moral, and political ideals for the audience—the kinds of features that are often bound up in our love for them—our trust in the artist's sincerity can take on additional dimensions, some that may be in tension with the narrower focus on specifically aesthetic sincerity that Nguyen has in mind. This can be understood in terms of what Nguyen calls a commitment to aesthetic *steadfastness* rather than sincerity. Think back to the kinds of considerations that led Dederer to identify with Woody Allen, such as his underdog nebbishness. Dederer felt betrayed by Allen because his personal behavior belied that identification, but we can also imagine a scenario in which Allen, in an act of genuine artistic sincerity, inverted his prior aesthetic sensibility and made a film starring himself as a stalwart leader, making the tough calls to save the day. This would be a different kind of betrayal, but a betrayal nonetheless. We can imagine a Woody Allen fan leaving the theater and saying: "What was that!? It certainly wasn't a Woody Allen movie." It's not that we expect artists to simply make

the same work over and over again (something Allen has plausibly been accused of doing in his later years), but that when artists have developed an aesthetic sensibility that grounds a strong identification among their fans, that leads them to expect the artist to innovate within that space rather than upending the values that have earned their fans' affection in the first place. When we judge that artists have compromised the values that ground that identification, it cuts because we feel like they've sold *us* out, earning our appreciation by expressing a commitment to values that they don't actually endorse or have abandoned. This is a more intimate kind of selling out, one that may not even involve a compromise of the artist's aesthetic sensibility for fame or fortune, but is perceived as a bait and switch by fans who have come to identify with their art.

To be sure, this process of identification involves the audience foisting considerable baggage onto the artist. Whether artists have any obligation to be artistically trust*worthy* with respect to steadfastness rather than sincerity is a separate question. Perhaps their only allegiance should be to aesthetic sincerity, and fans are fooling themselves by trusting their sense of self to artists whom they love. That's a real possibility. If it turns out artists have no obligation to be aesthetically steadfast, it may just mean that fans with sellout grievances have sold themselves a bill of goods.

Compare this with Mary Beth Willard's account of the specifically aesthetic betrayal that can arise in cases such as *The Cosby Show*. She writes:

> When we learn of Cosby's crimes, we feel betrayed, and I suggest our betrayal is primarily aesthetic: we cannot laugh at

his comedy. We are angered by his ethical failure, but we feel betrayed because his comedy relied on the authenticity of his insights. Someone who genuinely believes that women were his equals, could not have done what he did.[16]

This is a revealing analysis, but it also highlights a different kind of betrayal from the one I have been discussing here. The betrayal is primarily aesthetic, in Willard's account, because it is the presuppositions that allowed for Cosby's comedy to be funny that have been betrayed. As she puts it later: "When we try to separate the comedy from the comedian, we find there's nothing left of the joke." What's been taken away from us, then, is the laughter. What's been betrayed are the expectations that allowed for the comedy to work, which, for comedians like Cosby, Allen, and Louis C. K., whose identity is tied up with their work, is influenced by their personal lives as well. Perhaps this is the kind of criticism Roxanne Gay has in mind when she writes that Cosby's actions rendered his work "meaningless."[17] This is a different kind of betrayal from the more intimate emotional betrayal that can also accompany revelations about artists' immorality, though they are intertwined. Even the casual appreciator of *The Cosby Show* can be aesthetically betrayed in Willard's sense, but the fan who loves Cosby and identifies deeply with the show has something further to lose and faces an additional layer of betrayal.

This relates to our earlier discussion of whether an artist's actions can alter the personal meaning of the work for a fan who loves it. This kind of meaning can surface at both the individual and community level. Just as individuals can come to identify with certain artists and their work, so too can particular communities.

The significance of *The Cosby Show* for many Black viewers has been well documented, and Gay identifies with this aspect of the show as well, writing: "As a middle-class black girl, I was affirmed to see something of my life reflected back to me. Such representation was elusive and necessary and incredibly meaningful." Or as Wesley Morris puts it: "For at least half an hour, *The Cosby Show* kept at bay the tide of bad news from the outside world while never skimping on the glories and hassles of being alive. The show became the oasis we needed."[18] If Gay's comment about meaninglessness concerns the kind of aesthetic betrayal that Willard explains, then point taken. This does seem to be her target when she writes that Cosby "once created great art, and then he destroyed his great art." This is different from claiming that there's a moral objection to continuing to engage with Cosby's otherwise great work: it's the more all-encompassing claim that we considered in Chapter 1 that there's simply no longer any greatness there to appreciate. But the ease with which Gay also seems to detach from the personal meaning of *The Cosby Show* in light of Cosby's actions is far from universal. As we've seen, many art consumers *struggle* with the conflict of emotions presented by revelations about artistic immorality, and that difficulty is related in part to matters of meaning.[19] The personal meaning of an artist's work can also be bound up with associations that make the artist's immoral behavior complicate our relationship with the work significantly, but not to the extent that it is evacuated of meaning. This is the case for me and Bill Cosby.

My dad was a big Bill Cosby fan. I knew the chocolate cake routine by heart before I'd ever heard Cosby himself perform it. By the time I was in college, I had also become very familiar with a

Cosby bit called "Why Is There Air?" because of its relationship to philosophy. In the routine, Cosby talks about seeing the philosophy majors wandering around campus, asking abstruse questions such as "Why is there air?" Phys Ed majors like Cosby knew why there was air! For blowing up basketballs and soccer balls!

Once I started studying philosophy, my dad would bring this up periodically and laugh uproariously at the punch line. It was a fitting joke. My dad always claimed to be baffled by philosophy, even though he was endlessly supportive of my decision to pursue it professionally. When I started graduate school, he sent me a framed copy of the album cover to *Why Is There Air?* with an encouraging note on the back (my dad was always sending me clippings with little notes on them). I displayed that framed album cover on my desk for years.

I don't anymore. After the long-standing accusations of sexual assault against Cosby became common knowledge, I packed the album cover away. The only reason I didn't toss it was the note my dad had written on the back. He died in 2012. At the time, I couldn't bear to throw away anything that he had written to me—I'm still not sure I could. But for the life of me, I can't remember what that note on the framed Cosby album said, even though I've read it countless times. Whenever I was feeling doubt about my work or the decision to try to make it as a college professor, I only had to reach over and turn the frame around to read those comforting words. They're gone now. I don't know where that album cover is—but I've searched for it. Cosby's actions ruined his work for me, but they didn't make it meaningless.

In all of these contexts, whether we're considering the artistic quality of the work, its meaning for a community, or the esoteric

role it plays in a single person's life, we're left with the wrenching discomfort of our heartstrings being pulled in multiple directions. How do we relieve that emotional torque? We can abandon it all, art and artist, as Gay entreats. We can try to rend the two apart, pretending they're not parts of a whole. This is what Morris describes as the "impossible moral surgery that hopes to cut off the artist to save the art."[20] But as Morris's nod to impossibility acknowledges, these all-or-nothing approaches that promise comfort by drawing a firm line somewhere (anywhere!) are challenging to maintain.

The philosopher Robert Merrihew Adams has considered a version of this problem concerning the dependence of our lives, and the lives of those that we love, on historical tragedies. What is the right attitude to take toward a horror such as the First World War if, were it not for that event, you wouldn't even have been born? He considers the possibility that we should resist trying to form overall judgments in such cases, but rather, cordon off our feelings about the good aspects of things from those about the bad. This is evocative of Morris's impossible moral surgery—rather than trying to arrive at a place where we can resolve our conflicting feelings about Cosby and *The Cosby Show*, we just endeavor to keep them at arm's length from one another, condemning one while valuing the other.

Adams ultimately rejects this strategy. He notes the cost involved "in blocking integration of our attitudes . . . and in leaving our loves surrounded with a cloud of attitudes that are consistent with them, not in substance, but only in being kept out of reach in a sort of emotional *apartheid*."[21] This kind of emotional bifurcation doesn't relax the tension, but by artificially separating

our positive and negative experiences, simply leaves us of two minds (or two hearts) concerning the beloved works of unethical artists. It's as if you had two children who weren't getting along, and so you aimed to keep them from ever being in the same room. Not exactly a tenable solution.

From this perspective, our perennial question *"Can we separate the art from the artist?"* seems to have been doomed from the start. Perhaps we shouldn't aim to separate them at all, but rather forge a way forward that takes seriously the intimate relationship between art and artist, eschewing the pitfalls of impossible surgery, and allowing the possibility of a stable, if uncomfortable, emotional equipoise.

Philosophy sometimes begins with a way of looking at things, a perspective, rather than an argument. You might think of this as a different vantage point that reveals the best spot to build, or a lens that allows you to see elements of the world that are otherwise indiscernible. One such perspective is found in an aphorism by the Stoic philosopher Epictetus. It's always stuck with me, perhaps because it is as odd as it is illuminating. He wrote: "Everything has two handles: the one by which it may be carried, the other by which it may not. If your brother acts unjustly, don't lay hold on the action by the handle of his injustice, for by that it cannot be carried; but by the opposite, that he is your brother, that he was brought up with you; and thus you will lay hold on it, as it is to be carried."[22]

There's so much to unpack in this weird metaphor.[23] The brother who acts unjustly is another example in which we are faced with conflicting emotions—love for a family member, battling with contempt for their immoral action. The idea that this is

a situation we must reckon with and move forward from is evoked by the idea that it is a thing that must be carried with us. But we can't carry it in just any way! To focus on the injustice (or to carry the action by that handle) is untenable. Epictetus doesn't say why, but an answer is apparent from the cases that we've examined in this book. You can't approach *The Cosby Show* by foregrounding Cosby's actions. As both Gay and Willard explore, there doesn't seem to be any viable way forward there—Cosby's actions seem to destroy the work. But there's a different way to carry it. In the case of the brother who acts unjustly, Epictetus emphasizes your emotional connection with him, your history together (that he was brought up with you), and contends that this is the way to grapple with his unjust act. Crucially, this is not a way of ignoring the injustice or leaving it behind—after all, the two handles belong to the same thing. Rather, as I interpret it, the point concerns the attitude that we bear toward the injustice. By foregrounding our emotional connection with the work, its personal meaning, we offer ourselves a handle by which to carry the artist's immorality. The notion that it must be carried is salutary: it emphasizes that the artist's immorality is a *burden*, something that must be borne with us if we're to retain a connection with the work. After all, we could always simply leave the whole mess behind, art and artist together. But as I emphasized at the end of the last chapter, this kind of abandonment—or erasure—doesn't feel like a way of really reckoning with the injustice, of taking it seriously. It's the fact that we love these artists that makes their immorality so salient for us. Simply casting it aside can feel like an abdication of responsibility. In contrast, to find a way to engage with both the work and the artist's immorality that highlights the connection

between them, rather than trying to ignore it, sever it, or abandon both altogether—that's a handle by which we can carry it. Perhaps, to break slightly with Epictetus, it would be even better to recommend we grasp the situation by both handles, like the horns of the proverbial bull.

So, integrating our conflicting feelings requires, in the first place, allowing them to interact rather than trying to impose a division between them. In Chapter 1, we focused on how our *judgments* about the art and the artist can interact productively, but our emotions raise some different issues, especially against a backdrop where we already love a particular artist and their work. What might it mean to successfully integrate our love for an artist with our outrage at their immoral action? And what do we gain by focusing specifically on the art and our love of it, while keeping the artist's immoral actions in view?

Philosophers since Aristotle have discussed the seemingly paradoxical conflict of emotions that attends certain kinds of artwork, such as tragedy and horror. How can we *enjoy* being saddened and terrified by art? Why on earth would we seek out feelings that we otherwise labor to avoid? Whether or not philosophers' solutions are adequate to explain these paradoxes of horror and tragedy, they offer some helpful frameworks for thinking through emotional conflicts surrounding the art of immoral artists.

For example, on one account of the paradox of horror, we experience two different emotions that compete with each other, such as thrill and terror, and the terror, still unpleasant, is simply the price we pay for the thrill.[24] Critics of this theory will protest that the terror of horror is itself pleasurable, but when it comes to immoral artists, that approach seems a lot less convincing. If

when turning to a beloved work by an immoral artist we feel the competing emotions of enjoying the work but being angered by the artist, it doesn't seem like there's anything pleasant about our anger at the artist. So, perhaps in such cases it is accurate to say that our anger or disgust at the artist is ultimately the price we pay to continue enjoying the art, and that's a sacrifice we may be willing to make if we love the art enough. (But note that this is nothing like the claim that the artist's immorality is a price worth paying for their art to exist, as if Roman Polanski's sexual abuse were simply worth it in order to have his films—we're talking about our emotions here, not the artist's actions.) It's important to see that the way our vying emotions are integrated may not be altogether comfortable for us. Recognizing that your disgust at an artist is ultimately outweighed by your enjoyment of their work might leave you feeling guilty, for instance. But then, that's just another negative feeling to be factored into the emotional calculus that this approach to reconciling good art and bad artists would have us perform. Moreover, it's not unfamiliar to experience an emotional integration that is not perfectly harmonious. For example, moving to a new place can often feel bittersweet: the sadness of leaving friends behind mingled with the excitement of a fresh start. What makes bittersweet qualify as an integrated emotion is that the conflicting feelings interact with each other rather than being artificially bifurcated as they are when we suppress one of two opposed emotions.

According to another way of thinking about the paradoxes of horror and tragedy, our feelings aren't simply weighed against each other but instead actively inform and enhance one another. The pleasure you take in seeing a performance of *Romeo and Juliet*

doesn't simply outweigh the sorrow of the tragedy, but rather, is shaped and developed by it—what philosopher Marcia Eaton calls "a strange kind of sadness."[25] This seems to be the kind of experience Tyler Malone describes when he writes: "Embracing the bramble of imperfections and idiosyncrasies of an artist tends to make the work prick with even more strangeness and complexity."[26] Perhaps there are cases in which our negative feelings about the artist can deepen our response to their work. For example, if you already approach Gaugin's portraits with hesitation about their sexualizing gaze, learning more about Gaugin's life may well heighten the pathos you experience when viewing them, enhancing your aesthetic experience, if not in an enjoyable way. Again, the point is not that this somehow makes the artist's immorality worthwhile, as if some aesthetic payoff could justify their bad behavior. Rather, it's a perspective on how our emotional response to those misdeeds might bear on our experience of their work.

Both of these views offer models for how our feelings about the work of immoral artists might be integrated in different ways. But however we end up balancing the flavors of this emotional stew, the art itself is an indispensable tool we can use to calibrate our taste for it. We can see a prime example of this through Aristotle's account of the paradox of tragedy. For Aristotle, tragedy offers the opportunity for *catharsis*, an idea that is subject to multiple interpretations. On one view, catharsis involves the *expunging* of your emotions—you watch a horror movie and it allows you to release all of your pent-up fears. On another view, catharsis is about the *clarifying* of your emotions. Reading a tragedy offers the opportunity to home in on the source and nature of your own feelings of sadness.

According to the expunging interpretation, catharsis doesn't seem like an apt way of analyzing the emotional dimensions of engaging with the work of immoral artists. People don't watch Woody Allen movies and find that they've been able to evacuate their negative feelings about him. On the contrary, for many consumers, engaging with the work of immoral artists is bound to incite those negative feelings, leading some to avoid their art altogether. On the clarifying interpretation, however, the idea of catharsis can offer a helpful interpretative lens for our emotionally fraught experience with the work of immoral artists. This is because at an emotional level, we don't just respond to the wrongs of these individuals as if they were just anyone. As we saw in our discussion of feeling anger as opposed to the more participatory feeling of betrayal, we experience the misdeeds of artists whom we love in distinctive ways. In particular, because the way we know these artists is through their art, we experience their wrongs as the wrongs *of* the creators of these works—it generally feels different to learn about the wrongful actions of a beloved artist, as opposed to those of some other public figure, as illustrated by the case of Harvey Weinstein. Consequently, these works offer a potentially revealing window into understanding this particular kind of emotional experience. They can be cathartic in the sense that they can help us clarify the complex mix of competing emotions that attend loving an artist who is also a real shit.

In her essay "The Aptness of Anger," philosopher Amia Srinivasan argues that getting angry is a way of emotionally recognizing acts of injustice.[27] If acts of egregious immorality don't get you riled up, there's a worry that you're failing to adequately appreciate their badness, even if you grant that those acts are

indeed wrong. She compares this kind of emotional registering of injustice with aesthetic appreciation, suggesting that there's an importance to *appreciating* something beautiful over and above just knowing that it's beautiful. If someone consistently fails to appreciate beautiful things, even while claiming that they are beautiful, we may well worry that the person is missing something. This observation has special salience when it comes to the case of beloved immoral artists, whose wrongdoing is already tied up with our aesthetic preferences and experiences. What's vexing about these cases isn't coming to understand how some anonymous predator could act so wrongly—it's coming to grips with how that predator could be the very artist whom we'd loved. Registering the wrongdoing of these artists *as artists* is more fully achieved not in spite of their artwork, but through it. It is in this sense that continuing to engage with their work can be cathartic, allowing us to clarify our emotional response to their immorality specifically as the creators of artworks that we love.

As you already know, I have a lot of affection for Woody Allen's *Love and Death*. I graduated from college in 2007, so I was in the first wave of Facebook users (or The Facebook as it was called back then, somewhat ironically, since this is no doubt what everyone's grandparents call it now). Back then, listing your favorites was a focal point of the Facebook profile, and sure enough, I registered *Love and Death* as my favorite movie. Why did I make that choice? I thought the movie's sensibility (bookish, silly, philosophical, weird) said something about me, represented my taste. I can't say I really identified with Allen in precisely the way that Dederer did, but I definitely identified with his work. But loving the work of an immoral artist

doesn't need to result only in feelings of betrayal: it can also offer an agent for crystalizing my complicated feelings about Allen, who made art that I love but whose personal behavior disgusts me.

At the end of *Love and Death* (spoiler alert) Woody Allen's character is executed, and he delivers a monologue from beyond the grave before the credits roll and he dances off through the Russian landscape, accompanied by a scythe-wielding Death. During the monologue, he says this: "The important thing, I think, is not to be bitter. You know, if it turns out that there is a God, I don't think that he's evil. I think the worst you can say about him is that basically he's an underachiever." I can see how someone like Allen could write those lines, with their blasé attitude toward morality and responsibility, while still allowing them to be funny, perhaps even apt. To be clear, I don't think there's much value in interpreting Allen's work in relation to events that are alleged to have taken place some 20 years later—the point is that when I watch this movie and reflect on why I love it, the tension between my feelings about the movie and my feelings about Allen ultimately gets resolved. I can hold them both consistently—my appreciation for the movie and my disdain for the artist—even for a work that Allen is so imbued with, having written, directed, and starred in it. In the abstract, it's easier to conflate the artist and the artwork and allow our conflicting feelings to become a confused muddle. But in engaging with the work, I find the focus of my various emotions is clarified, even when Allen himself is all over the movie. The point isn't to separate the art from the artist, but in watching the film I also discover that the art isn't equivalent to the artist. I anticipate my favorite scenes, and sure enough, they're still

funny, even keeping Allen's actions firmly in view. I find that I still love this movie.

This doesn't mean I still want to identify *Love and Death* as my favorite movie. I don't want Allen to represent me anymore: as we discussed in Chapter 2, that would have a public meaning that I don't endorse. I haven't seen a new Woody Allen movie in a decade, and I don't have any plans to. Nevertheless, I find that turning toward the artwork that I love, rather than spurning it, is cathartic in the clarifying sense—I emerge on the other end with my feelings of affection and disdain just as present, but also balanced, more clearly focused.

This example is just a report of my own experience with a beloved artwork and its unethical creator. Returning to a treasured work of art might also clarify your conflicting feelings by indicating that there's nothing left to love about the work: it might clarify your emotions in the direction of loathing for the artist and nostalgia for a work that once inspired but now repulses you. The idea of catharsis invoked here doesn't prescribe any particular conclusion. But there's nothing easy or obvious about how to work through these complex emotions without actually doing the work. Rather, it's a process of discovery. And *that* shouldn't be surprising at all. Neither art nor our emotions are well known for being transparent.

So, where does this leave us? The matters discussed in this book are messy, to be sure, but I don't want them to be obscure—as my dad was fond of cautioning, "Muddy waters seem deep." I want to be sure to leave you with a view to the bottom so we know where we stand.

An artist's biography, including their immorality, can influence our interpretation of their work, and it's possible that their abuses

and bigotries can render their art aesthetically worse. There's no general moral obligation to weed the work of immoral artists out of your life, but the spirited embrace of such work in public can have a meaning that can land you in ethical hot water. The best way to pursue moral change in the art world is through institutional reform rather than canceling particular artists. It makes sense to feel intimate emotions, such as betrayal, when the artists we love do or say terrible things, leaving us with the hard work of finding ways to integrate or resolve our conflicting emotions.

If there's been a theme to this book, it's that *all* of it matters—the art, the artist, their actions, and the relationships among them. Some would have us focus on the artist's immorality and forget their art. Others act as if art is so important that an artist's behavior can't touch it. Both of these perspectives are mistaken. It's ultimately irrelevant whether we can separate the art from the artist, because we shouldn't. The reason we care in the first place about immoral artists, as distinct from any other immoral person, is *because* they are artists, and, at the risk of stating the obvious, they are artists because they make art. That art is an ineliminable element as we determine how to reckon with immoral artists. If we leave out the art, we forget what made the questions in this book salient to us to begin with, but moreover, we ignore one of art's distinctive values. One of the reasons we care about art is that it offers us ways of grappling with our place in the world—ways of interpreting our emotions, ways of clarifying human character, ways of understanding the beautiful and the sublime, the evil and the absurd. Art sits at the center of our struggles with immoral artists, offering us a handle by which to grasp the problem. We would be fools not to seize it.

NOTES

CHAPTER 1

1. (BBC News 2019)
2. (Carroll 2001)
3. (Gaut 1998)
4. (Stear 2019) identifies a more complicated kind of artworks, "seductive" artworks, that prescribe that the audience have certain responses, such as shame, regarding responses that the artwork elicited earlier on. He argues that this kind of artwork poses a problem for a specific argument that takes the normative approach: the Merited Response Argument. If the second response (that critiques the first response) is merited, that must mean the first response was not merited, and so was an aesthetic flaw. But this absurdly entails that all seductive artworks are flawed. His solution is to build in a condition that allows that unmerited responses aren't necessarily aesthetic flaws if they stem entirely from an aesthetically worthwhile constraint of the work. This is in essence a way of bracketing the initial "unmerited" response that a seductive artwork first elicits, treating it as a constraint that allows us to have the aesthetically worthwhile experience of critically reflecting on that response itself, without thinking that the first response is an aesthetic flaw of the work. It's less clear how this intriguing discussion would apply to the problem of immoral artists. Moreover, the normative approach I take here does not embrace the *pro tanto* requirement of Gaut's original Merited Response Argument: I do not hold that any and all ethical flaws of the artist *must* to that extent be aesthetic flaws. It depends on how they relate to plausible interpretation of the work.
5. (Anderson 2015)

6. (D'Arms and Jacobsen 2000)

7. (Gaut 2007, 240)

8. (Gaut 2007, 240)

9. (Cf. D'Arms and Jacobsen 2000, 80–81.) See also (Carroll June 4, 2019).

10. For one way of approaching the connection, see (Simon 2019).

11. (Bartel 2019) develops a similar view, also expanding on Gaut's ethicism, about how an artist's biography (including their morality) can be relevant to how we interpret a work's point of view, or the attitudes it prescribes. The approach I take here is somewhat broader. Artists' lives can influence how we interpret their work not only through our understanding of the attitudes prescribed by the work but also in terms of whether the prescribed attitudes are merited.

12. This view is most strongly associated with (Beardsley and Wimsatt 1987).

13. For further commentary on the difference between the work's prescribed response and the artist's intention, see (Eaton 2003).

14. (Mack 2018)

15. (Gaut 2007, 251)

16. See (Stear 2020) for a careful discussion of the distinction between eliciting and endorsing and how it bears on debates about the ethical criticism of art. At 163, Stear argues that the kind of artistic constraint placed by the artist endorsing an unethical response isn't itself an aesthetic flaw of a work anymore than any other artistic constraint (such as a certain poetic meter), even if it makes certain aesthetic flaws more likely. But I think that caveat is fine for my purposes. We don't need to claim that the artist's endorsement of an unethical response is itself an aesthetic flaw of their work, only that this constraint influences the kinds of responses it is appropriate to have toward the work should it aim to elicit them.

17. (Bartel 2019)

18. (Barthes 1977)

19. (Cf. Bartel 2019)

20. (Davies 2020)

21. (Cf. Wollheim 1980)

22. (Carroll 1996), (Eaton 1992)
23. Compare with the case of a stubbed toe in (Eaton 2003, 173).
24. (Carroll 1996, 234)
25. (Carroll 1996)
26. For broader discussion of how a person's immorality might taint objects associated with them (including their artwork), see (Harold 2020).
27. The version of immoralism that I focus on here is Eaton's robust immoralism (Eaton 2012). Eaton does note that her reading of the immoralist aims of many artworks is both conceptual and normative (285), but this is consistent with the success conditions for immoralist aesthetic achievements being understood in primarily descriptive terms (e.g., the work succeeds when it is in fact successful in getting the audience to overcome their resistance to a character's immorality). Indeed, this is the kind of language that Eaton uses in the remainder of the paper.
28. A perfect example from (Clavel-Vazque 2018).
29. (Clavel-Vazque 2018)
30. Art by Hannibal Lecter is also considered by (Wills and Holt, 2017).
31. (McGrath 2012). Philosophers have discussed this point in terms of whether a kind of admirable "single-mindedness" might justify or excuse certain concomitant immoral acts, such as Gaugin abandoning his family to pursue painting in Tahiti. See, for example, (Eaton 1992).

CHAPTER 2

1. (Powers 2019)
2. (Gross and Nussbaum 2019)
3. (Hegarty 2019)
4. (Hiller 2014)
5. Though philosophers have defended every possible position, including that the dead can be harmed. See (Ridge 2003).
6. (Cf. Strohl and Willard 2018)
7. (Vance 2017)
8. (Martin 2016)
9. (Martin 2016, 205)

10. (Martin 2016, 210)
11. (Cf. Riggle 2015)
12. For discussion of moral constraints that may apply to this form of ethical consumerism, see (Hussain 2012).
13. (Archer and Matheson 2019)
14. (Korsgaard 1996)
15. (Strohl and Willard 2018)
16. (Garber 2019)
17. (Tosi and Warmke 2016, 199)
18. (Tosi and Warmke 2016, 216)
19. (Nguyen and Williams forthcoming)
20. (Abad-Santos 2019)
21. For discussion of the difference between norms for responding to fiction versus non-fiction, see (Jacobson 1997, 186). For relevant discussion of art and moral knowledge, see, for example, (Kieran 2006).
22. (Monteiro 2017)
23. For a defense of enjoying gory films, see (Stoner 2020).
24. (Nussbaum 2019). Thanks to James Harold for cluing me into this.
25. (Radcliffe 2020)
26. (Chadwick 2017)
27. (Malone 2019)
28. (Heti 2018)
29. (Stephens 2019)
30. For helpful discussion of the political instrumentalizing of art, see (HolyWhiteMountain and Strohl 2019).

CHAPTER 3

1. (Koblin 2018)
2. (Tsioulcas 2020)
3. (Romano 2019)
4. On the "automatic" nature of common responses to immoral artists, see also (Strohl and Willard 2017).
5. (Various 2020)

6. (Rini 2018, 346)
7. (Smith 2021)
8. For an overview of philosophical approaches to punishment, please see (Bedau and Kelly 2019).
9. (Romano 2018)
10. (Graham-Dixon 2010)
11. (Rea 2019)
12. (Nayeri 2019)
13. (Pogrebin and Schuessler 2018)
14. (Archer and Matheson 2019)
15. (Archer and Matheson 2019, 257)
16. (Malone 2019)
17. (Ratajkowski 2020), (Testa 2020)
18. (Morris 2019)
19. (Williams and Zraick 2019)
20. (Zraick 2019)
21. (Rodney 2017)
22. (Callcut 2019)
23. (Zellner 2019)
24. (Jonze 2019)
25. (Barnes 2017)
26. (Wittgenstein 1953, 272)
27. (Daseler 2018)
28. (Nwanevu 2019)
29. (Cf. Malik 2020)
30. (Táíwò 2020)
31. (Lewis 2020)
32. (Coates 2019)
33. (Stephens 2020)
34. (Dickie 1974)
35. (Rini 2020)
36. (Senior 2019)
37. For a philosophical example of this approach, see (Alcoff 1991–1992).

38. (Grady 2020)
39. (Lee and Low Books 2020)
40. (Jawort 2019)
41. I've written about cultural appropriation in (Matthes 2016 and 2019).
42. (Bowles 2020)
43. (Flood 2020)
44. For more, see (de Leon, Alter, et al. 2020).
45. (Horowitz, 2016)
46. (Cascone 2019)
47. (Nochlin 1971)
48. (Simpson and Srinivasan 2018)
49. (De Gallier 2018)
50. (Barnes 2018)
51. (Cooper 2014)
52. (Kendall 2016)
53. (Yar and Bromwich 2019)
54. (Emerick 2016, 2)
55. (Ross 2019)

CHAPTER 4

1. (Grady 2019)
2. (Jonze 2019)
3. Compare with Strawson's account of the reactive attitudes (Strawson 1974).
4. (Baier 1986)
5. (Riggle 2015)
6. (Riggle 2015)
7. (Dederer 2017)
8. (Bradpiece 2019)
9. (Korsgaard 1996)
10. (Flanagan 2020)
11. (Bromwich 2018)
12. (Fischer 2020)

13. This discussion draws on (Matthes 2018b).
14. (Mills 2018)
15. (Nguyen forthcoming)
16. (Willard 2020, 41)
17. (Gay 2018)
18. (Morris 2017)
19. I take this to be a different kind of tension than the "delicious state of irresolvable conflict with ourselves" that Eaton describes in arguing for the aesthetic value of rough heroes, no doubt because the source of moral concern stems from the artist rather than a character in the work (Eaton 2012, 287).
20. (Eaton 2012, 287)
21. (Adams 2006, 251)
22. (Epictetus 135, 43)
23. This discussion of Epictetus draws on (Matthes 2018a).
24. The views here are helpfully summarized in (Carroll 1995).
25. (Eaton 1982)
26. (Malone 2019)
27. (Srinivasan 2018, 132)

BIBLIOGRAPHY

Abad-Santos, Alex. 2019. "The Fight over Joker and the New Movie's 'Dangerous' Message, Explained." *Vox*. September 25. https://www.vox.com/culture/2019/9/18/20860890/joker-movie-controversy-incel-sjw.

Adams, Robert Merrihew. 2006. "Love and the Problem of Evil." *Philosophia* 34: 243–251.

Alcoff, Linda. 1991–1992. "The Problem of Speaking for Others." *Cultural Critique* 20: 5–32.

Anderson, Luvell. 2015. "Racist Humor." *Philosophy Compass*: 1–9.

Archer, Alfred, and Benjamin Matheson. 2019. "Should We Mute Michael Jackson?" *Prindle Post*. May 24. https://www.prindlepost.org/2019/05/should-we-mute-michael-jackson/.

Archer, Alfred, and Benjamin Matheson. 2019. "When Artists Fall: Honoring and Admiring the Immoral." *Journal of the American Philosophical Association*: 246–265.

Baier, Annette. 1986. "Trust and Antitrust." *Ethics* 96 (2): 231–260.

Barnes, Brooks. 2017. "Kevin Spacey Cut from 'All the Money in the World,' with Role Recast." *New York Times*. November 8. https://www.nytimes.com/2017/11/08/arts/kevin-spacey-all-the-money-in-the-world.html.

Barnes, Brooks. 2018. "In Ending 'Roseanne,' ABC Executive Makes Her Voice Heard." *New York Times*. May 29. https://www.nytimes.com/2018/05/29/business/media/channing-dungey-roseanne.html.

Bartel, Christopher. 2019. "Ordinary Monsters: Ethical Criticism and the Lives of Artists." *Contemporary Aesthetics* 17.

Barthes, Roland. 1977. "The Death of the Author." *Image-Music-Text*. New York: Fontana Press.

BBC News. 2019. "R. Kelly faces bribery charge of 1994 marriage to Aaliyah." *BBC*. December 2019. https://www.bbc.com/news/entertainment-arts-50682084#:~:text=Kelly%20has%20been%20charged%20with,Kelly%20was%2027.

Beardsley, Monroe, and William K. Wimsatt. 1987. "The Intentional Fallacy." In *Philosophy Looks at the Arts*, edited by Joseph Margolis. Philadelphia: Temple University Press.

Bedau, Hugo Adam, and Erin Kelly. 2019. "Punishment." *The Stanford Encyclopedia of Philosophy*. https://plato.stanford.edu/archives/win2019/entries/punishment/.

Bowles, David. 2020. "'American Dirt' Is Proof the Publishing Industry Is Broken." *New York Times*. January 27. https://www.nytimes.com/2020/01/27/opinion/american-dirt-book.html.

Bradpiece, Sam. 2019. "Michael Jackson Fans Sue Singer's Alleged Abuse Victims for 'Damaging Memory of the Dead.'" CNN. July 14. https://www.cnn.com/2019/07/14/europe/france-michael-jackson-case-intl/index.html.

Bromwich, Jonah Engel. 2018. "Everyone Is Canceled." *New York Times*. June 28. https://www.nytimes.com/2018/06/28/style/is-it-canceled.html.

Callcut, Daniel. 2019. "Paul Gauguin, the National Gallery and the Philosophical Conundrum of Exhibiting Immoral Artists." *Prospect*. October 16. https://www.prospectmagazine.co.uk/philosophy/paul-gauguin-the-national-gallery-and-the-philosophical-conundrum-of-exhibiting-immoral-artists.

Carroll, Noel. 1995. "Why Horror?" In *Arguing about Art*, edited by Alex Neill and Aaron Ridley. London: Routledge.

Carroll, Noel. 1996. "Moderate Moralism." *British Journal of Aesthetics* 36 (3): 223–238.

Carroll, Noel. 2001. "Beauty and the Genealogy of Art Theory." In *Beyond Aesthetics*. Cambridge: Cambridge University Press.

Carroll, Noel. 2019. "When Is Someone 'Just Joking'?" *New Statesman*. June 4.

Cascone, Sarah. 2019. "A New Campaign to End Unpaid Internships in the Art World Exposes a Problematic Reliance on Free Labor." *Artnet News*. July 18. https://news.artnet.com/art-world/a-call-to-end-unpaid-internships-in-the-art-world-1603792.

Chadwick, Kayla. 2017. "I Don't Know How to Explain to You That You Should Care about Other People." *Huffington Post*. June 26. https://www.huffpost.com/entry/i-dont-know-how-to-explain-to-you-that-you-should_b_59519811e4b0f078efd98440.

Clavel-Vazque, Adriana. 2018. "Sugar and Spice, and Everything Nice: What Rough Heroines Tell Us about Imaginative Resistance." *Journal of Aesthetics and Art Criticism* 76 (2): 201–212.

Coates, Ta-Nehisi. 2019. "The Cancelation of Colin Kaepernick." *New York Times*. November 22. https://www.nytimes.com/2019/11/22/opinion/colin-kaepernick-nfl.html.

Cooper, Brittney. 2014. "Iggy Azalea's Post-Racial Mess: America's Oldest Race Tale, Remixed." *Salon*. https://www.salon.com/2014/07/15/iggy_azaleas_post_racial_mess_americas_oldest_race_tale_remixed/.

D'Arms, J., and D. Jacobsen. 2000. "The Moralistic Fallacy: On the 'Appropriateness' of Emotion." *Philosophy and Phenomenological Research* 61: 65–90.

Davies, Sally. 2020. "Gentileschi. Let us not allow sexual violence to define the artist. *Psyche*. Accessed July 16. https://psyche.co/ideas/gentileschi-let-us-not-allow-sexual-violence-to-define-the-artist

Daseler, Graham. 2018. "The Bad and the Beautiful." *American Conservative*. July 27. https://www.theamericanconservative.com/articles/the-bad-and-the-beautiful/.

Dederer, Claire. 2017. "What Do We Do with the Art of Monstrous Men?" *Paris Review*. November 20. https://www.theparisreview.org/blog/2017/11/20/art-monstrous-men/.

De Gallier, Thea. 2018. "'I Wouldn't Want This for Anybody's Daughter': Will #MeToo Kill Off the Rock'n'Roll Groupie?" *The Guardian*. March 15. https://www.theguardian.com/music/2018/mar/15/i-wouldnt-want-this-for-anybodys-daughter-will-metoo-kill-off-the-rocknroll-groupie.

de Leon, Concepcion, Alexandra Alter, et al. 2020. "'A Conflicted Cultural Force': What It's Like to Be Black in Publishing. *New York Times.* July 1. https://www.nytimes.com/2020/07/01/books/book-publishing-black.html.

Dickie, George. 1974. *Art and the Aesthetic: An Institutional Analysis.* Ithaca, NY: Cornell University Press.

Eaton, A. W. 2003. "Where Ethics and Aesthetics Meet: Titian's Rape of Europa." *Hypatia* 18 (4): 159–188.

Eaton, A. W. 2012. "Robust Immoralism." *Journal of Aesthetics and Art Criticism* 70 (3): 281–292.

Eaton, Marcia M. 1982. "A Strange Kind of Sadness." *Journal of Aesthetics and Art Criticism* 41 (1): 51–63.

Eaton, Marcia Muelder. 1992. "Integrating the Aesthetic and the Moral." *Philosophical Studies* 67: 219–240.

Emerick, Barrett. 2016. "Love and Resistance: Moral Solidarity in the Face of Perceptual Failure." *Feminist Philosophy Quarterly* 2 (2): 1–21.

Epictetus. 135. *The Enchiridion.* Translated by Elizabeth Carter. Accessed July 19, 2020. http://classics.mit.edu/Epictetus/epicench.html.

Fischer, Molly. 2020. "Who Did J. K. Rowling Become? Deciphering the Most Beloved, Most Reviled Children's Book Author in History." *The Cut.* December 22. https://www.thecut.com/article/who-did-j-k-rowling-become.html.

Flanagan, Caitlin. 2020. "I Actually Read Woody Allen's Memoir." *The Atlantic.* June 7. https://www.theatlantic.com/ideas/archive/2020/06/i-read-woody-allen-memoir/612736/.

Flood, Alison. 2020. "US Publishing Remains 'as White Today as It Was Four Years Ago.'" *The Guardian.* January 30. https://www.theguardian.com/books/2020/jan/30/us-publishing-american-dirt-survey-diversity-cultural-appropriation.

Garber, Megan. 2019. "Aziz Ansari and the Physics of Moving Forward." *The Atlantic.* July 11. https://www.theatlantic.com/entertainment/archive/2019/07/aziz-ansaris-netflix-special-ego-meets-id/593674/.

Gaut, Berys. 1998. "The Ethical Criticism of Art." In *Aesthetics and Ethics*, edited by Jerrold Levinson. Cambridge: Cambridge University Press.

Gaut, Berys. 2007. *Art, Emotion, and Ethics.* Oxford University Press.

Gay, Roxanne. 2018. "Can I Enjoy the Art but Denounce the Artist?" *Marie Claire*. February 6. https://www.marieclaire.com/culture/a16105931/roxane-gay-on-predator-legacies/.

Grady, Constance. 2019. "What Do We Do When the Art We Love Was Created by a Monster?" *Vox*. June 25. https://www.vox.com/culture/2018/10/11/17933686/me-too-separating-artist-art-johnny-depp-woody-allen-michael-jackson-louis-ck.

Grady, Constance. 2020. "Black Authors Are on All the Bestseller Lists Right Now. But Publishing Doesn't Pay Them Enough." *Vox*. June 17. https://www.vox.com/culture/2020/6/17/21285316/publishing-paid-me-diversity-black-authors-systemic-bias.

Graham-Dixon, Andrew. 2010. *Caravaggio: A Life Sacred and Profane*. Penguin: London.

Gross, Terry, and Emily Nussbaum. 2019. "We All Watch in Our Own Way: A Critic Tracks the 'TV Revolution.'" NPR. July 15. https://www.npr.org/2019/07/15/741146427/we-all-watch-in-our-own-way-a-critic-tracks-the-tv-revolution.

Harold, James. 2020 *Dangerous Art*. Oxford University Press.

Hegarty, Siobhan. 2019. "Like Michael Jackson and R. Kelly's Songs but Not Them? Ethical Approaches for How to Deal with It." ABC. March 20. https://www.abc.net.au/life/ethics-for-dealing-with-artists-like-michael-jackson-r-kelly/10921262.

Heti, David. 2018. "Can We Separate the Art from the Artist?" *Aesthetics for Birds*. December 6. https://aestheticsforbirds.com/2018/12/06/can-we-separate-the-art-from-the-artist/#heti.

Hiller, Avram. 2014. "A 'Famine, Affluence, and Morality' for Climate Change?" *Public Affairs Quarterly* 28 (1): 19–39.

HolyWhiteMountain, Sterling, and Matt Strohl. 2019. "Sterling HolyWhiteMountain on Blood Quantum, 'Native Art,' and Cultural Appropriation." *Aesthetics for Birds*. January 31. https://aestheticsforbirds.com/2019/01/31/sterling-holywhitemountain-on-blood-quantum-native-art-and-cultural-appropriation/.

Horowitz, Andy. 2016. "Who Should Pay for the Arts in America?" *The Atlantic*. January 31. https://www.theatlantic.com/entertainment/

archive/2016/01/the-state-of-public-funding-for-the-arts-in-america/
424056/.

Hussain, Waheed. 2012. "Is Ethical Consumerism an Impermissible Form of Vigilantism?" *Philosophy & Public Affairs* 40 (2): 111–143.

Jacobson, Daniel. 1997. "In Praise of Immoral Art." *Philosophical Topics* 25 (1): 155–199.

Jawort, Adrian L. 2019. "The Dangers of the Appropriation Critique." *Los Angeles Review of Books*. October 5. https://lareviewofbooks.org/article/the-dangers-of-the-appropriation-critique/.

Jonze, Tim. 2019. "Bigmouth Strikes Again and Again: Why Morrissey Fans Feel So Betrayed." *The Guardian*. May 30. https://www.theguardian.com/music/2019/may/30/bigmouth-strikes-again-morrissey-songs-loneliness-shyness-misfits-far-right-party-tonight-show-jimmy-fallon.

Kendall, Mikki. 2016. "Why Are the Oscar Nominees So White? Because the Academy Doesn't Want to Change." *Washington Post*. January 15. https://www.washingtonpost.com/posteverything/wp/2016/01/15/why-are-the-oscar-nominees-so-white-because-the-academy-doesnt-want-to-change/.

Kieran, Matthew. 2006. "Art, Morality and Ethics: On the (Im)Moral Character of Art Works and Inter-Relations to Artistic Value." *Philosophy Compass* 1–2: 129–143.

Koblin, John. 2018. "After Racist Tweet, Roseanne Barr's Show Is Canceled by ABC." *New York Times*. May 29, 2018. https://www.nytimes.com/2018/05/29/business/media/roseanne-barr-offensive-tweets.html.

Korsgaard, Christine. 1996. *The Sources of Normativity*. New York: Cambridge University Press.

Lee and Low Books. 2020. "Where Is the Diversity in Publishing? The 2019 Diversity Baseline Survey Results." *The Open Book Blog*. January 28. https://blog.leeandlow.com/2020/01/28/2019diversitybaselinesurvey/.

Lewis, Helen. 2020. "How Capitalism Drives Cancel Culture." *The Atlantic*. July 14. https://www.theatlantic.com/international/archive/2020/07/cancel-culture-and-problem-woke-capitalism/614086/.

Mack, David. 2019. "Louis C.K. Reportedly Joked 'I Like to Jerk Off and I Don't Like Being Alone." *Buzzfeed*. January, 18, 2019. https://www.buzzfeednews.com/article/davidmack/louis-ck-jerk-off-parkland

Malik, Nesrine. 2020. "For a Few Weeks, Black Lives Mattered. Now What?" *The Guardian*. June 21. https://www.theguardian.com/commentisfree/2020/jun/21/black-lives-mattered-revolt-cultural-debate-hostile-establishment.

Malone, Tyler. 2019. "On John Wayne, Cancel Culture, and Art of Problematic Artists." *Literary Hub*. June 21. https://lithub.com/on-john-wayne-cancel-culture-and-the-art-of-problematic-artists/.

Martin, Adrienne M. 2016. "Factory Farming and Consumer Complicity." In *Philosophy Comes to Dinner*, edited by Andrew Chignell, Terence Cuneo, and Matthew C. Halteman. New York: Routledge, 203–214.

Matthes, Erich Hatala. 2016. "Cultural Appropriation without Cultural Essentialism?" *Social Theory and Practice* 42 (2): 343–366.

Matthes, Erich Hatala. 2018a. "Who Owns Up to the Past? Heritage and Historical Injustice." *Journal of the American Philosophical Association* 4 (1): 87–104.

Matthes, Erich Hatala. 2018b. "Can Today's Artists Still Sell Out?" *Aesthetics for Birds*. September 13. https://aestheticsforbirds.com/2018/09/13/artworld-roundtable-can-todays-artists-still-sell-out/#matthes.

Matthes, Erich Hatala. 2019. "Cultural Appropriation and Oppression." *Philosophical Studies* 176 (4): 1003–1013.

McGrath, Charles. 2012. "Good Art, Bad People." *New York Times*. June 21.

Mills, Claudia. 2018. "Artistic Integrity." *Journal of Aesthetics and Art Criticism* 76 (1): 9–20.

Monteiro, Lyra D. 2017. "How to Love Problematic Pop Culture." *Medium*. August 27. https://medium.com/@intersectionist/how-to-love-problematic-pop-culture-4f9ab9161836.

Morris, Wesley. 2017. "How to Think about Bill Cosby and 'The Cosby Show.'" *New York Times*. June 18. https://www.nytimes.com/2017/06/18/arts/television/how-to-think-about-bill-cosby-and-the-cosby-show.html.

Morris, Wesley. 2019. "Michael Jackson Cast a Spell. 'Leaving Neverland' Breaks It." *New York Times.* February 28. https://www.nytimes.com/2019/02/28/arts/television/michael-jackson-leaving-neverland.html.

Nayeri, Farah. 2019. "Is It Time Gauguin Got Canceled?" *New York Times.* November 18. https://www.nytimes.com/2019/11/18/arts/design/gauguin-national-gallery-london.html.

Nguyen, C. Thi. Forthcoming. "Trust and Sincerity in Art." *Ergo.*

Nguyen, C. Thi, and Bekka Williams. 2020. "Moral Outrage Porn." *Journal of Ethics and Social Philosophy.* 18(2): 147-172.

Nochlin, Linda. 1971. "Why Have There Been No Great Women Artists?" *ARTnews.* January.

Nussbaum, Emily. 2019. *I Like to Watch: Arguing My Way through the TV Revolution.* Random House.

Nwanevu, Osita. 2019. "The 'Cancel Culture' Con." *New Republic.* September 23. https://newrepublic.com/article/155141/cancel-culture-con-dave-chappelle-shane-gillis.

Pogrebin, Robin, and Jennifer Schuessler. 2018. "Chuck Close Is Accused of Harassment. Should His Artwork Carry an Asterisk?" *New York Times.* January 28. https://www.nytimes.com/2018/01/28/arts/design/chuck-close-exhibit-harassment-accusations.html.

Powers, Ann. 2019. "Before and After: What's It Like Listening to Michael Jackson Now." NPR. May 11. https://www.npr.org/2019/05/11/722198385/before-and-after-listening-to-michael-jackson-and-accusers.

Radcliffe, Daniel. 2020. "Daniel Radcliffe Responds to J. K. Rowling's Tweets on Gender Identity." *Trevor Project.* June 8. https://www.thetrevorproject.org/2020/06/08/daniel-radcliffe-responds-to-j-k-rowlings-tweets-on-gender-identity/.

Ratajowski, Emily. 2020. "Buying Myself Back. When Does a Model Own Her Own Image?" *The Cut.* September 15. https://www.thecut.com/article/emily-ratajkowski-owning-my-image-essay.html.

Rea, Naomi. 2019. "Artist Kehinde Wiley's Latest Paintings Are a Progressive Riposte to Paul Gauguin's Primitivist Portraits of Tahitians."

Artnet News. May 15. https://news.artnet.com/art-world/kehinde-wiley-tahiti-gauguin-1546054.

Ridge, Michael. 2003. "Giving the Dead Their Due." *Ethics* 114 (1): 38–59.

Riggle, Nick. 2015. "On the Aesthetic Ideal." *British Journal of Aesthetics* 55 (4): 433–447.

Rini, Regina. 2018. "How to Take Offense: Responding to Microaggression." *Journal of the American Philosophical Association*: 332–351.

Rini, Regina. 2020. "The Internet Is an Angry and Capricious God." *Times Literary Supplement.* Accessed July 18. https://www.the-tls.co.uk/articles/the-internet-is-an-angry-and-capricious-god/.

Rodney, Seph. 2017. "George W. Bush's Paintings Cannot Redeem Him." *Hyperallergic.* March 28. https://hyperallergic.com/368002/george-w-bushs-paintings-cannot-redeem-him/.

Romano, Aja. 2018. "The Sexual Assault Allegations against Kevin Spacey Span Decades. Here's What We Know." *Vox.* December 24. https://www.vox.com/culture/2017/11/3/16602628/kevin-spacey-sexual-assault-allegations-house-of-cards.

Romano, Aja. 2019. "Why We Can't Stop Fighting about Cancel Culture." *Vox.* December 30. https://www.vox.com/culture/2019/12/30/20879720/what-is-cancel-culture-explained-history-debate.

Ross, Loretta. 2019. "I'm a Black Feminist. I Think Call-Out Culture Is Toxic." *New York Times.* August 17. https://www.nytimes.com/2019/08/17/opinion/sunday/cancel-culture-call-out.html.

Simon, Scott. 2019. "Paintings by Adolf Hitler Are 'Unremarkable,' So Why Forge Them?" *NPR.* February 9. https://www.npr.org/2019/02/09/692855767/opinion-paintings-by-adolf-hitler-are-unremarkable-so-why-forge-them.

Senior, Jennifer. 2019. "Teen Fiction and the Perils of Cancel Culture." *New York Times.* March 8. https://www.nytimes.com/2019/03/08/opinion/teen-fiction-and-the-perils-of-cancel-culture.html.

Simpson, Robert Mark and Amia Srinivasan. 2018. "No Platforming." *Academic Freedom*, edited by Jennifer Lackey. Oxford: Oxford University Press, 186–209.

Smith, Alan. 2021. "Rep. Jim Jordan Laments New House Rules, 'Cancel Culture.'" NBCNews.com. January 14. https://www.nbcnews.com/politics/congress/live-blog/2021-01-13-trump-impeachment-25th-amendment-n1253971/ncrd1254027#blogHeader.

Srinivasan, Amia. 2018. "The Aptness of Anger." *Journal of Political Philosophy* 26 (2): 123–144.

Stear, Nils-Hennes. 2019. "Meriting a Response: The Paradox of Seductive Artworks." *Australasian Journal of Philosophy* 97 (3): 465–482.

Stear, Nils-Hennes. 2020. "Fatal Prescription." *British Journal of Aesthetics* 60 (2): 151–163.

Stephens, Bret. 2019. "The Scandal of a Nobel Laureate." *New York Times*. October 17. https://www.nytimes.com/2019/10/17/opinion/peter-handke-nobel-prize.html.

Stephens, Bret. 2020. "Reading Orwell for the Fourth of July." *New York Times*. July 3. https://www.nytimes.com/2020/07/03/opinion/orwell-fourth-of-july.html.

Stoner, Ian. 2020. "Barbarous Spectacle and General Massacre: A Defence of Gory Fictions." *Journal of Applied Philosophy* 37 (4): 511–527.

Strawson. P. F. 1974. *Freedom and Resentment and Other Essays*. New York: Routledge.

Strohl, Matt, and Mary Beth Willard. 2017. "Aesthetics, Morality, and a Well-Lived Life." *Daily Nous*. November 21. https://dailynous.com/2017/11/21/philosophers-art-morally-troubling-artists/.

Strohl, Matt, and Mary Beth Willard. 2018. "Can We Separate the Art from the Artist?" *Aesthetics for Birds*. December 6. https://aestheticsforbirds.com/2018/12/06/can-we-separate-the-art-from-the-artist/#strohlwillard.

Táíwò, Olúfẹ́mi O. 2020. "Identity Politics and Elite Capture." *Boston Review*. May 7. http://bostonreview.net/race/olufemi-o-taiwo-identity-politics-and-elite-capture.

Testa, Jessica. 2020. "The Nude Pictures That Won't Go Away." *New York Times*. November 12. https://www.nytimes.com/2020/11/12/style/jonathan-leder-photographer-emily-ratajkowski-modeling.html.

Tosi, Justin, and Brandon Warmke. 2016. "Moral Grandstanding." *Philosophy and Public Affairs* 44 (3): 197–217.

Tsioulcas, Anastasia. 2020. "Publisher Drops Woody Allen's Book after Ronan Farrow Objects, Employees Walk Out." NPR. March 6. https://www.npr.org/2020/03/06/812687472/after-woody-allens-memoir-was-signed-book-publisher-s-employees-walk-out.

Vance, Chad. 2017. "Climate Change, Individual Emissions, and Foreseeing Harm." *Journal of Moral Philosophy* 14: 562–584.

Various. 2020. "A Letter on Justice and Open Debate." *Harper's Magazine.* July 7. https://harpers.org/a-letter-on-justice-and-open-debate/.

Willard, Mary Beth. 2020. "Cosby, Comedy, and Aesthetic Betrayal." *Philosophers Magazine* 88 (1): 36–41.

Williams, Timothy, and Karen Zraick. 2019. "Samuel Little Is Most Prolific Serial Killer in U.S. History, F.B.I. Says." *New York Times.* October 7. https://www.nytimes.com/2019/10/07/us/serial-killer-samuel-little.html.

Wills, Bernard, and Jason Holt. 2017. "Art by Jerks." *Contemporary Aesthetics* 15 (1).

Wittgenstein, Ludwig. 1953. *Philosophical Investigations.* Oxford: Blackwell.

Wollheim, Richard. 1980. "Criticism as Retrieval." In *Art and Its Objects.* Cambridge: Cambridge University Press, 185–205.

Yar, Sanam, and Jonah Engel Bromwich. 2019. "Tales from the Teenage Cancel Culture." *New York Times.* November 2. https://www.nytimes.com/2019/10/31/style/cancel-culture.html.

Zellner, Xander. "'Surviving R. Kelly' Doc Finale Spurred 116% Gain in R. Kelly Music Streams." *Billboard.* January 10. https://www.billboard.com/articles/columns/chart-beat/8492984/r-kelly-docuseries-caused-gain-music.

Zraick, Karen. 2019. "F.B.I. Hopes Samuel Little's Drawings Will Help Identify His Murder Victims." *New York Times.* February 13. https://www.nytimes.com/2019/02/13/us/samuel-little-serial-killer.html.

INDEX

For the benefit of digital users, indexed terms that span two pages (e.g., 52–53) may, on occasion, appear on only one of those pages.